FLORA

COLORING BOOK
ILLUSTRATED BY MARIA TROLLE

Gibbs Smith

To my Family

26 25 24 23 8 7 6 5

Flora
Illustrations © 2019 Maria Trolle.
www.mariatrolle.se
Instagram: @maria_trolle

Swedish edition copyright © 2019 Pagina Förlags AB, Sweden.
All rights reserved.

Gibbs Smith
P.O. Box 667
Layton, Utah 84041

1.800.835.4993 orders
www.gibbs-smith.com

ISBN: 978-1-4236-5355-4

THIS BOOK BELONGS TO:

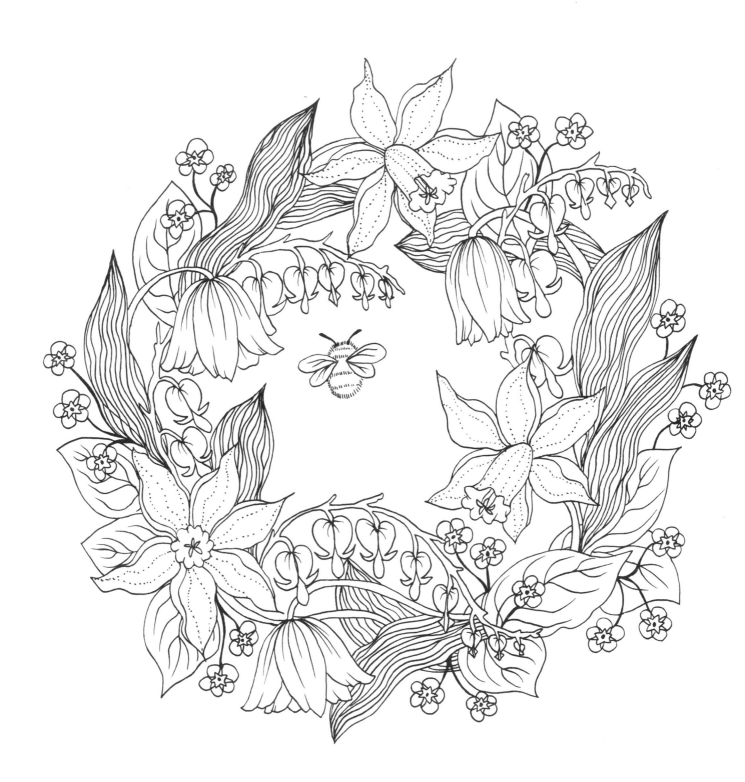

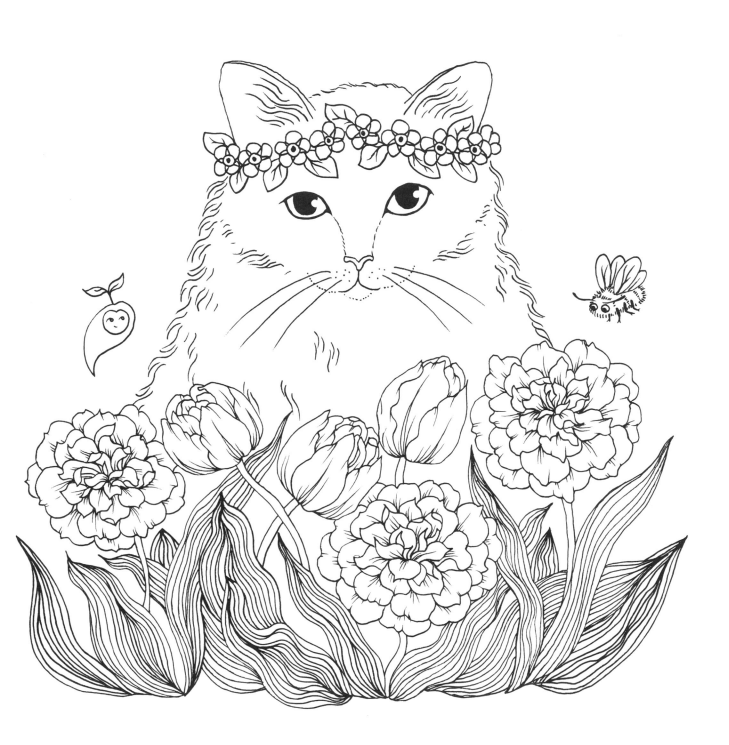

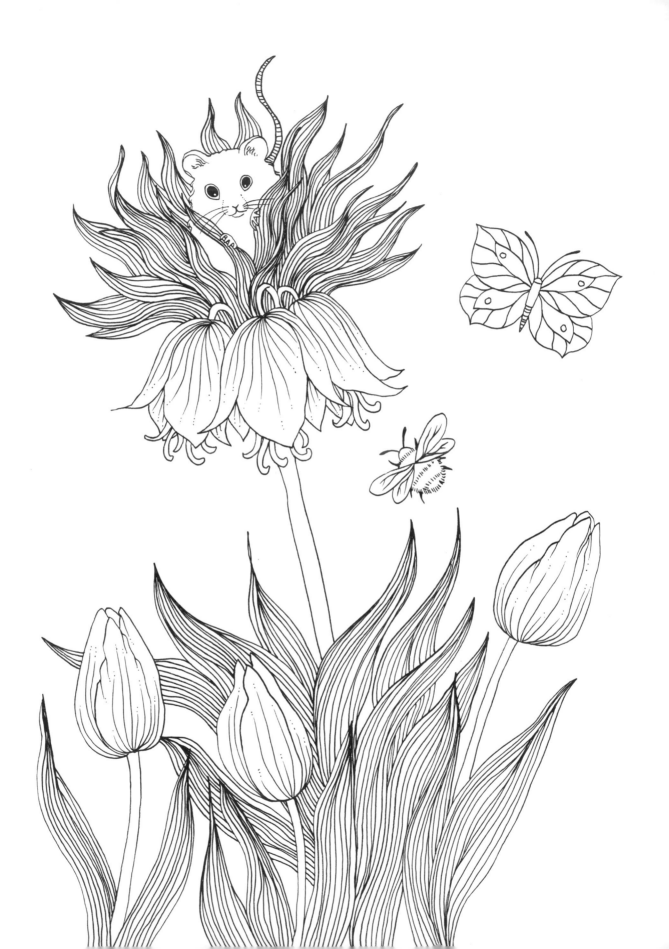

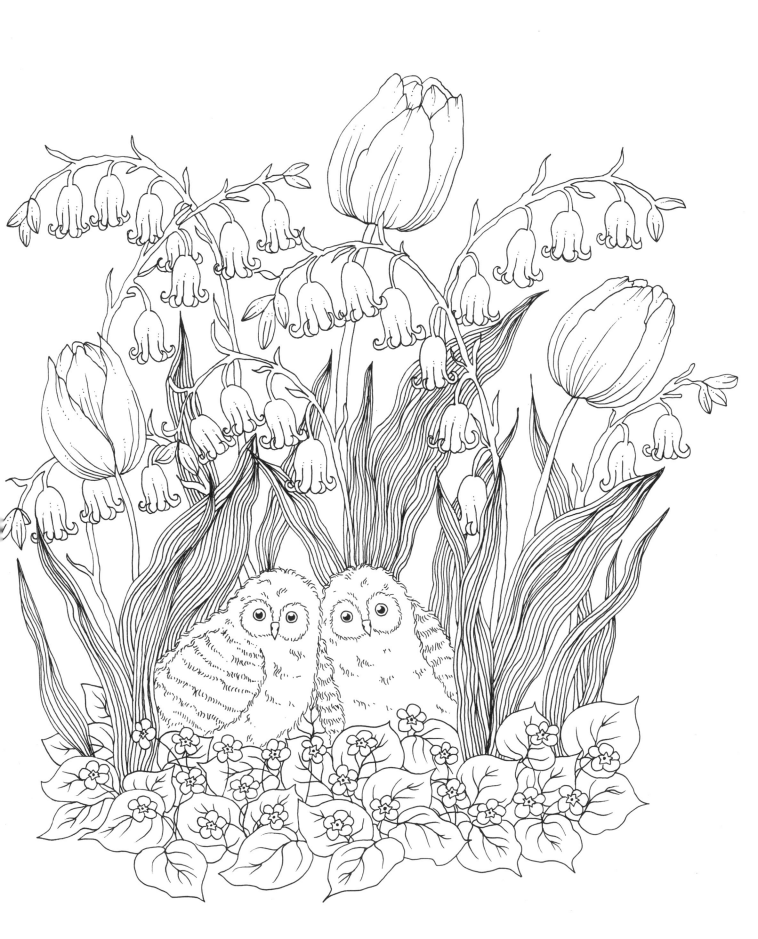

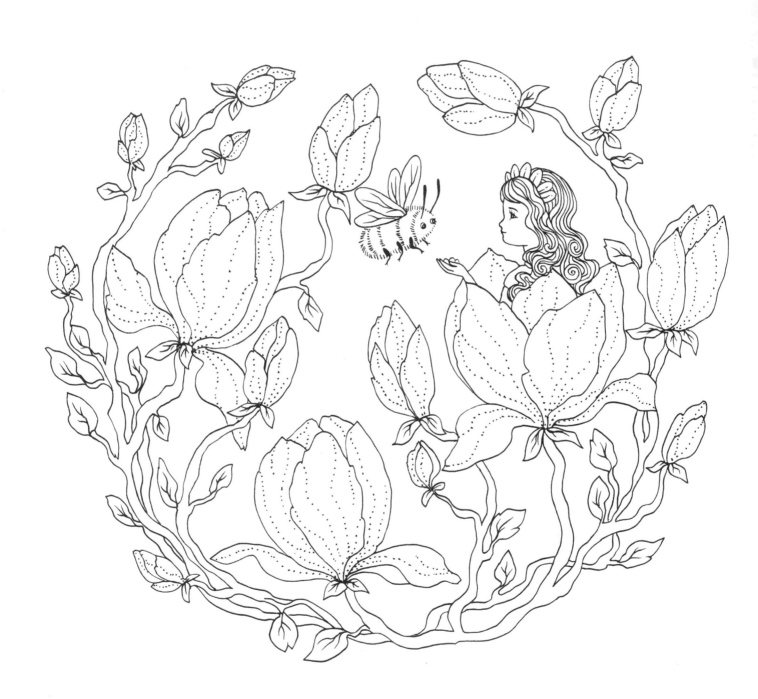

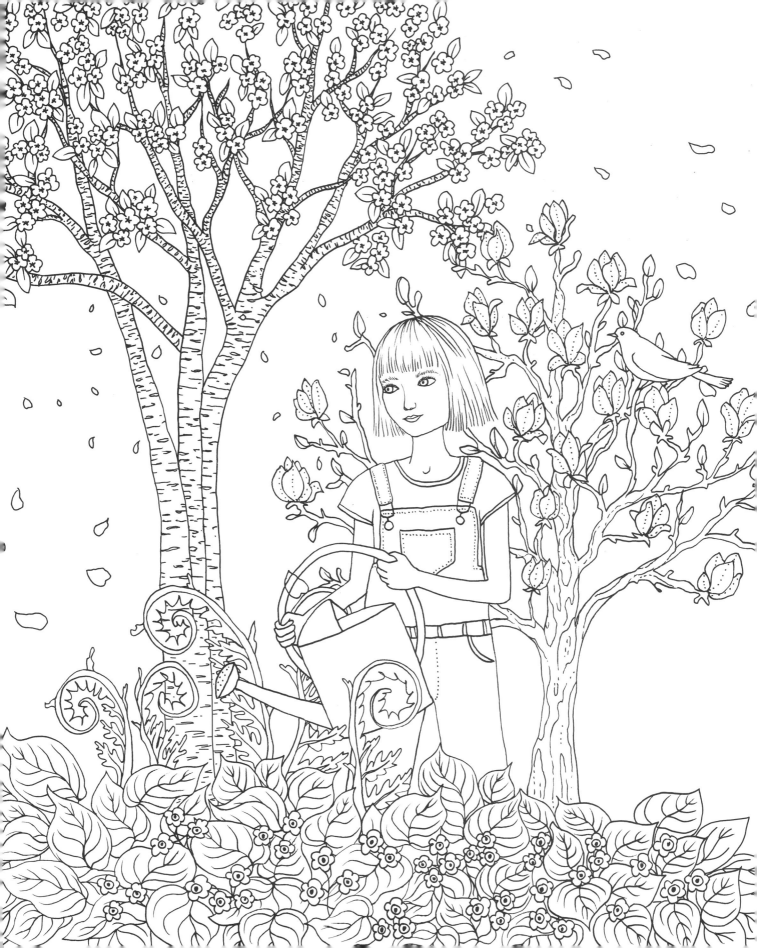

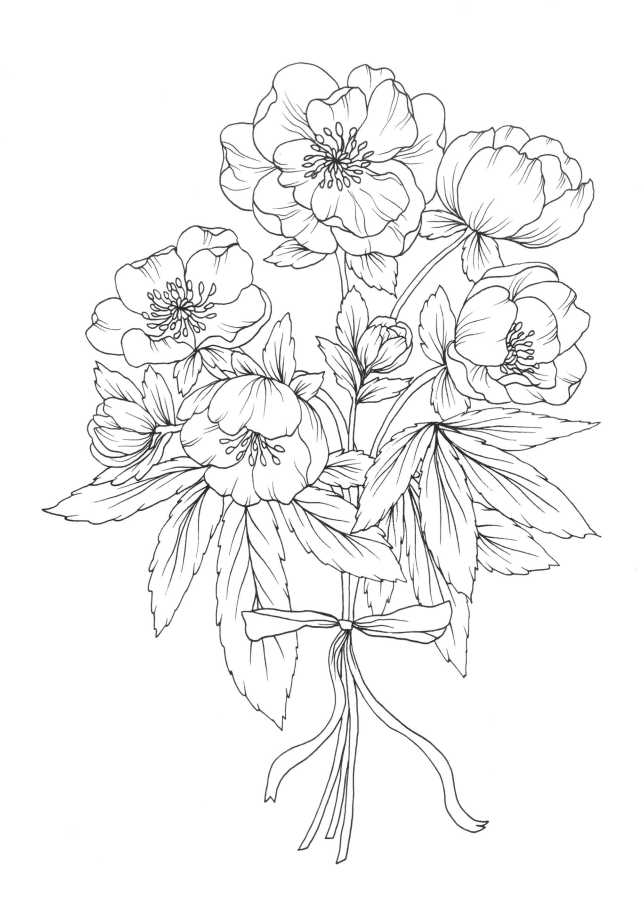

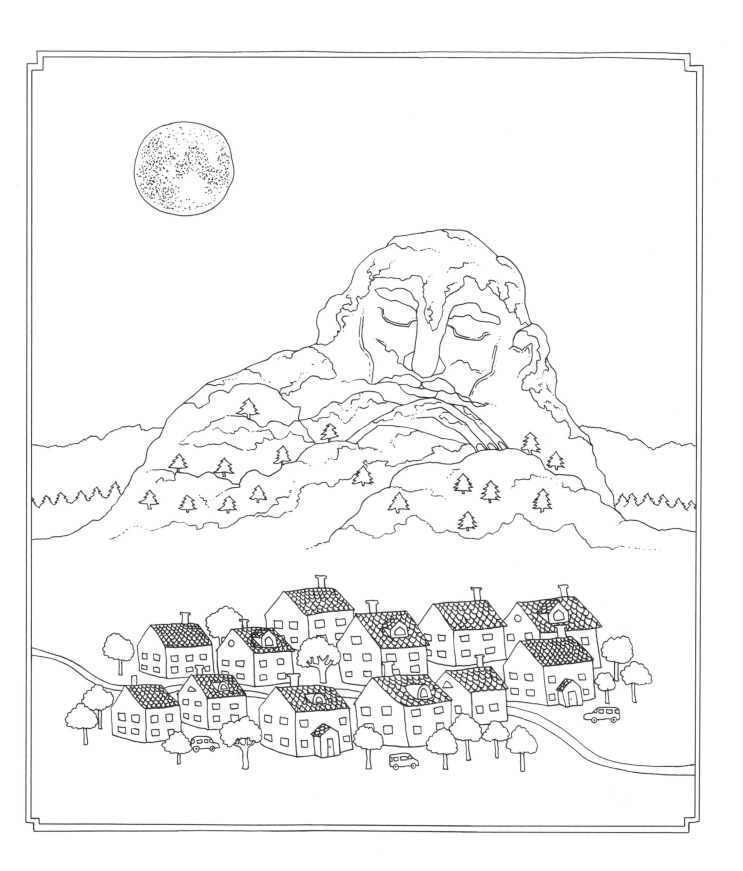

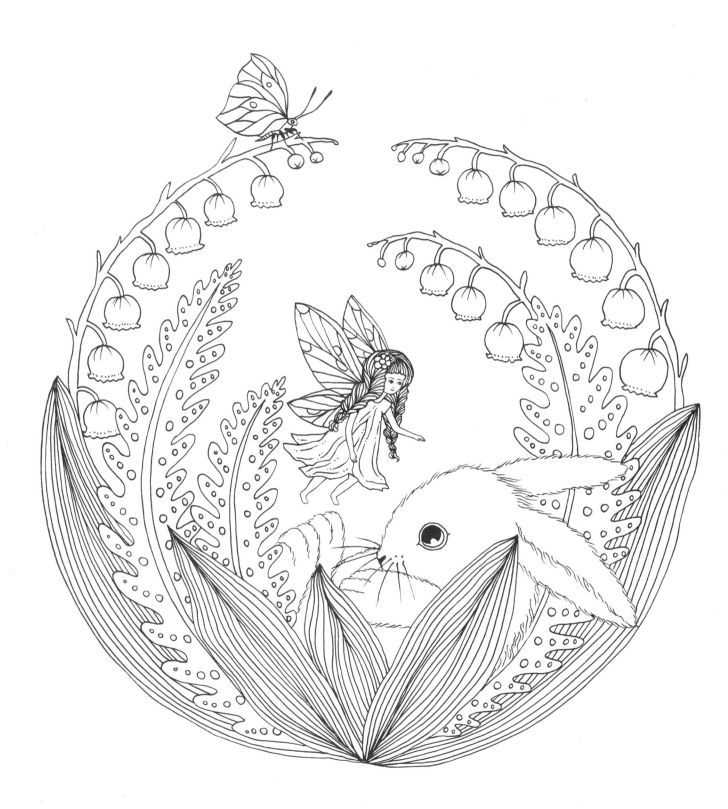

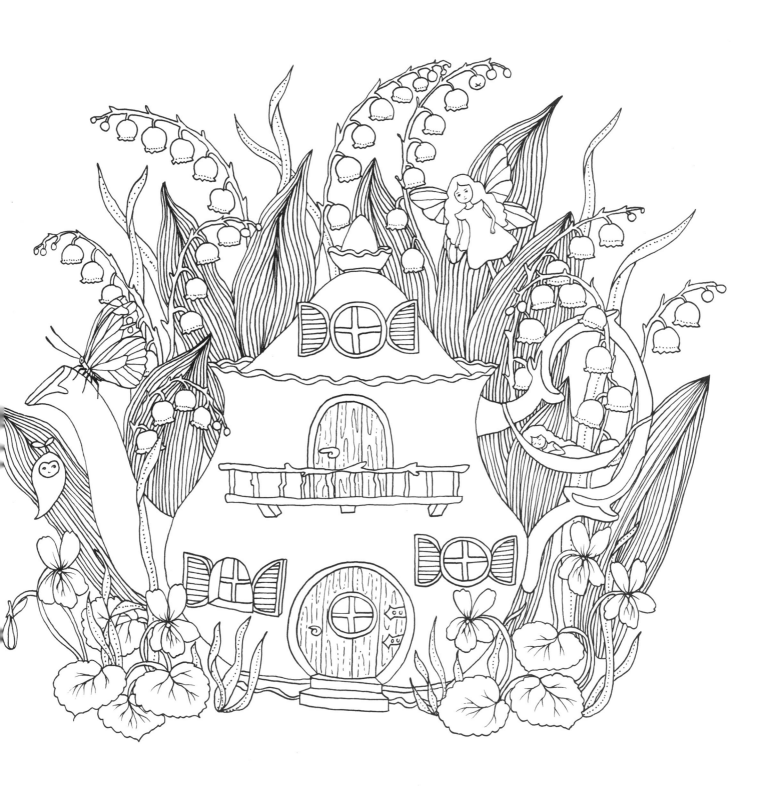

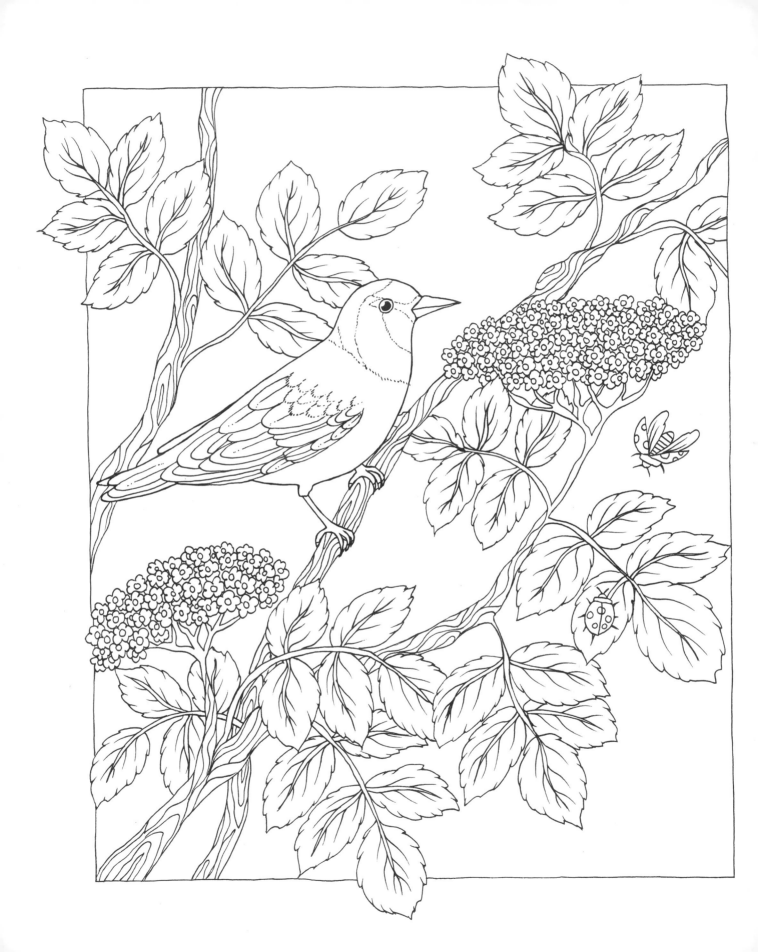

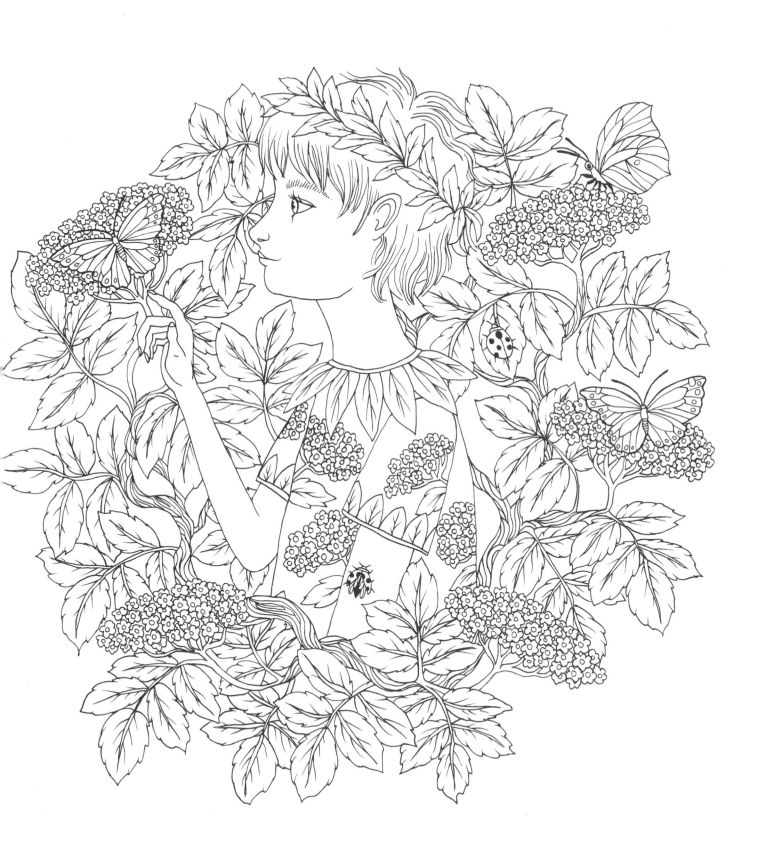

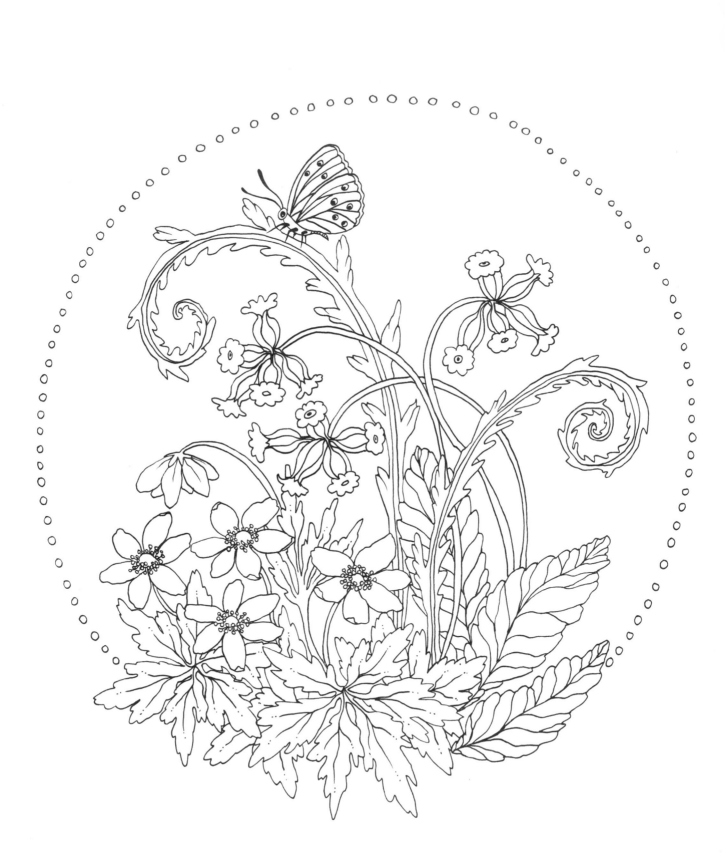

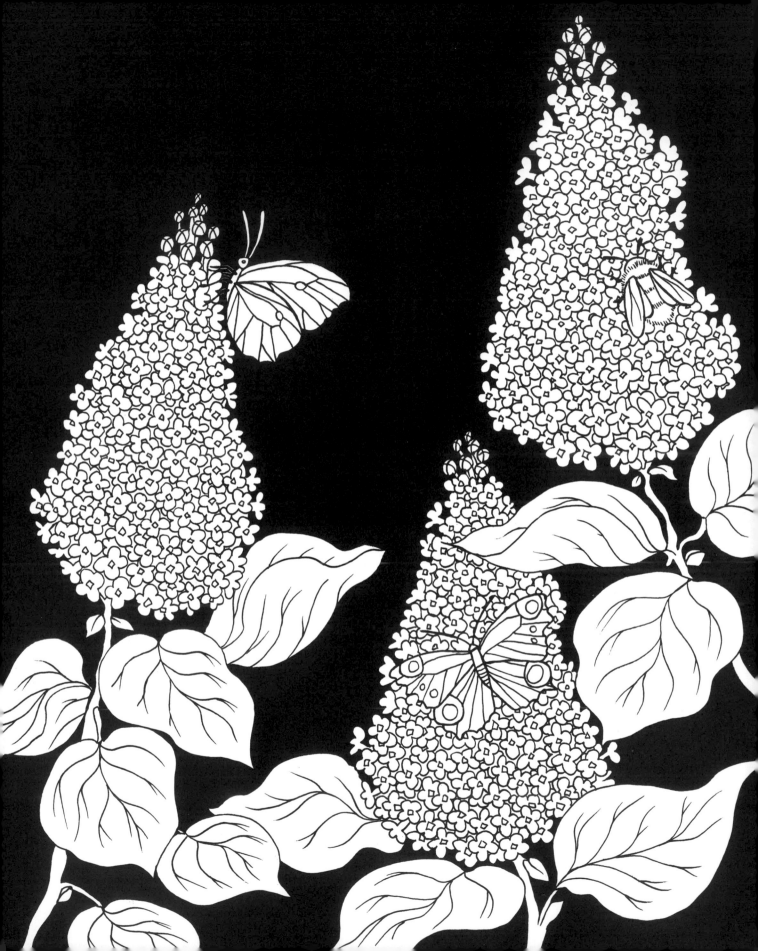

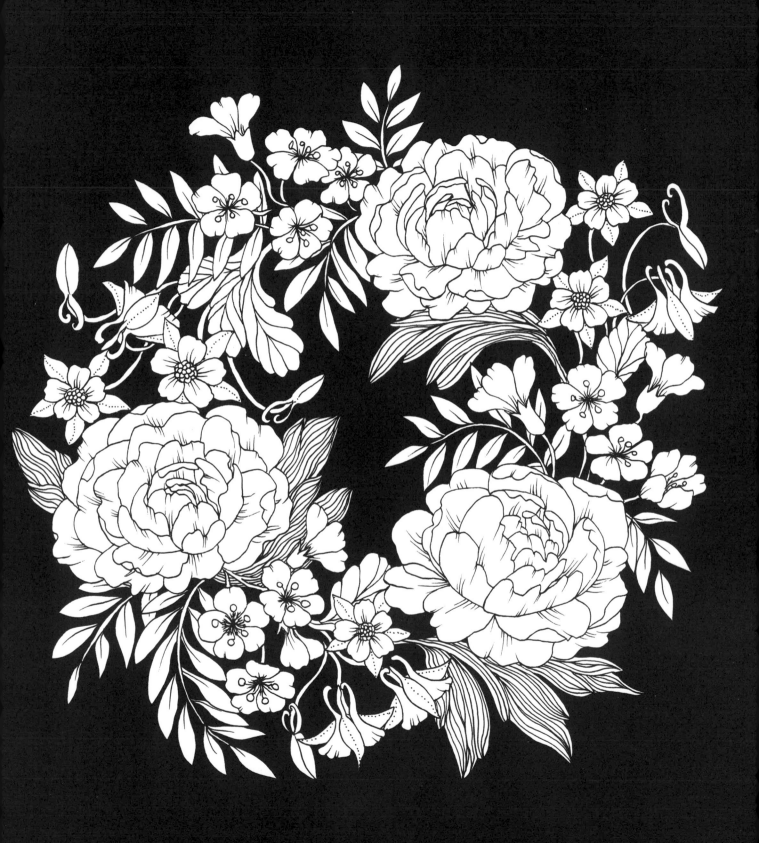

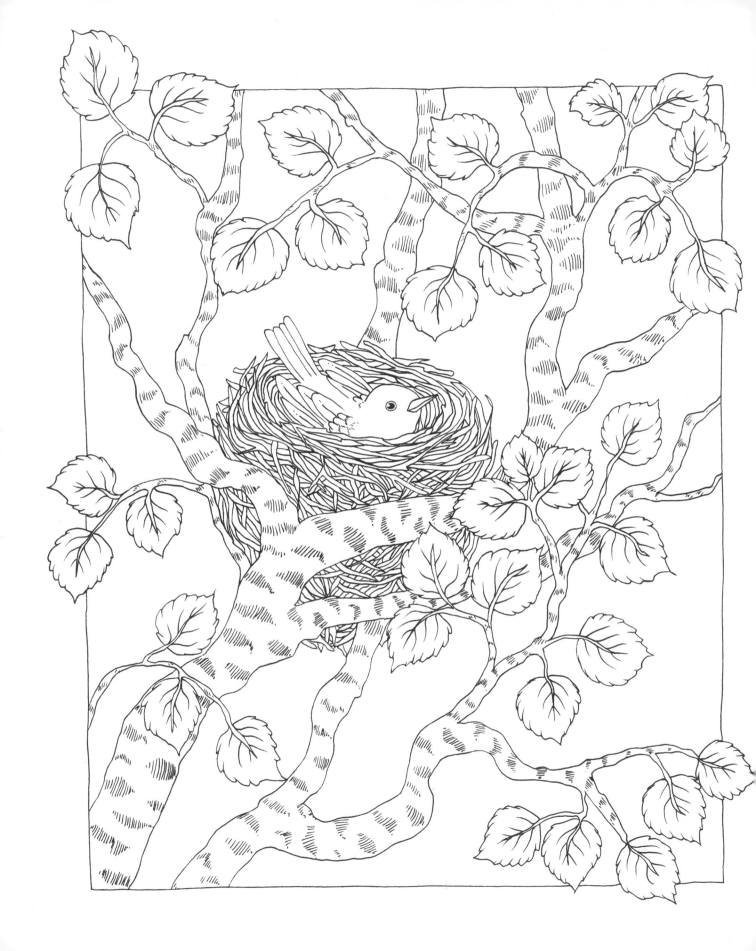

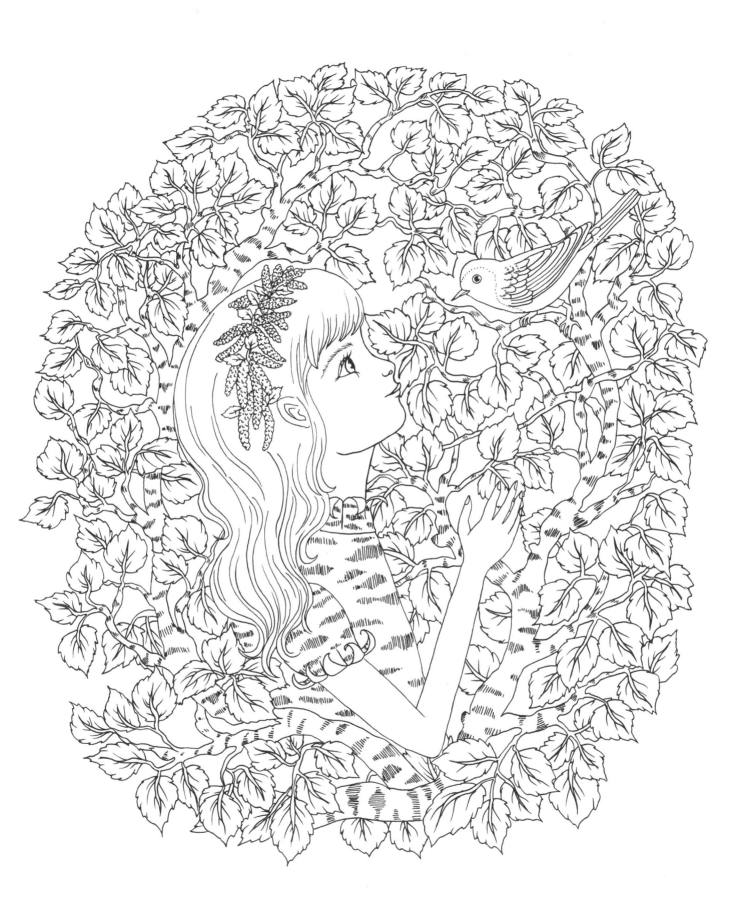

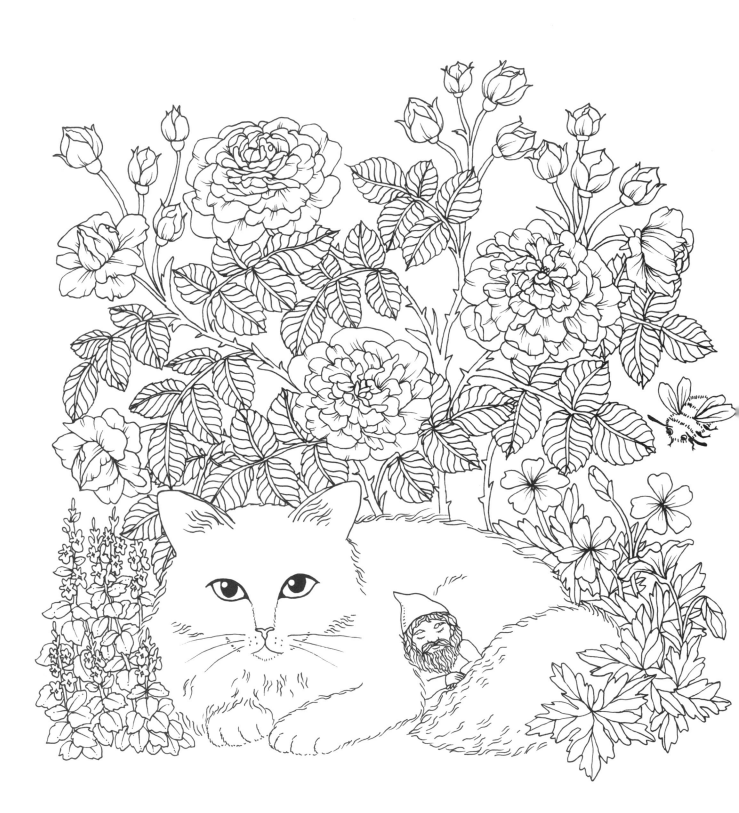

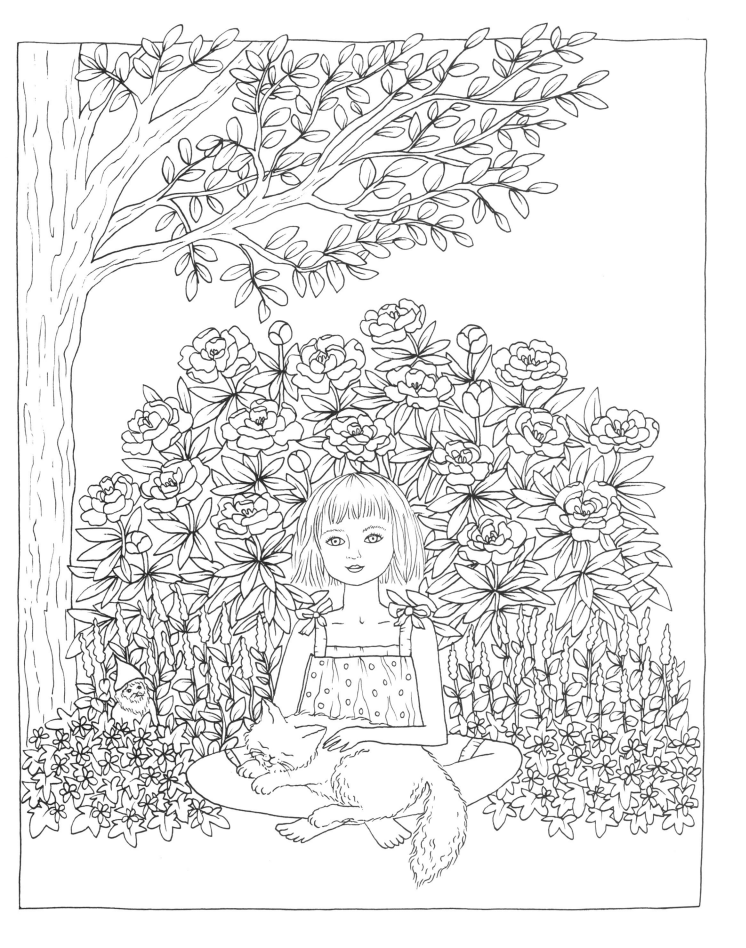

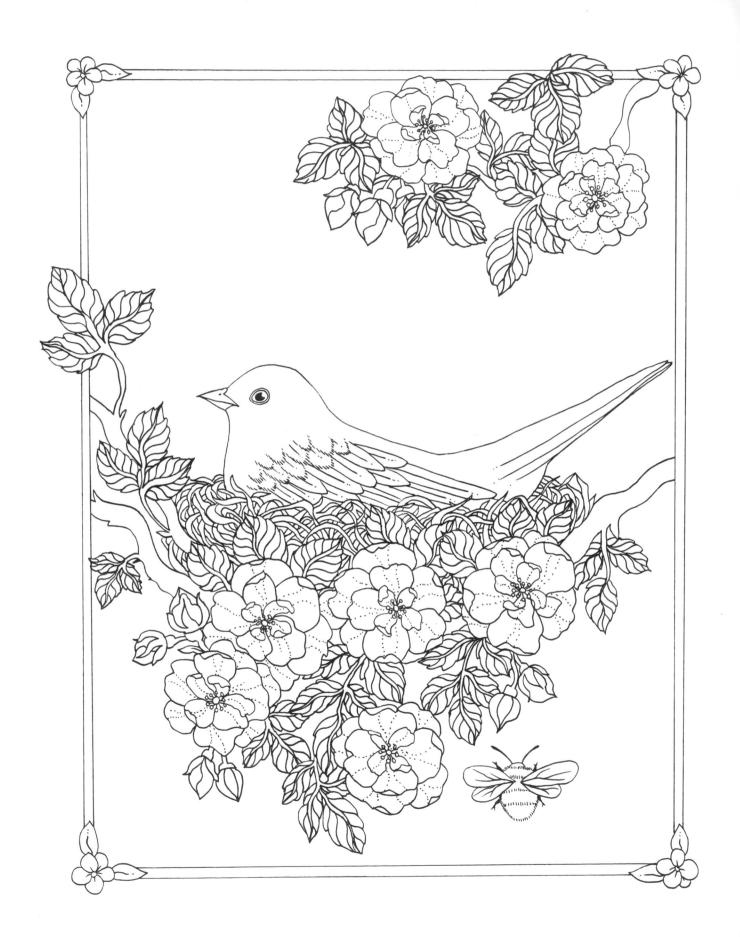

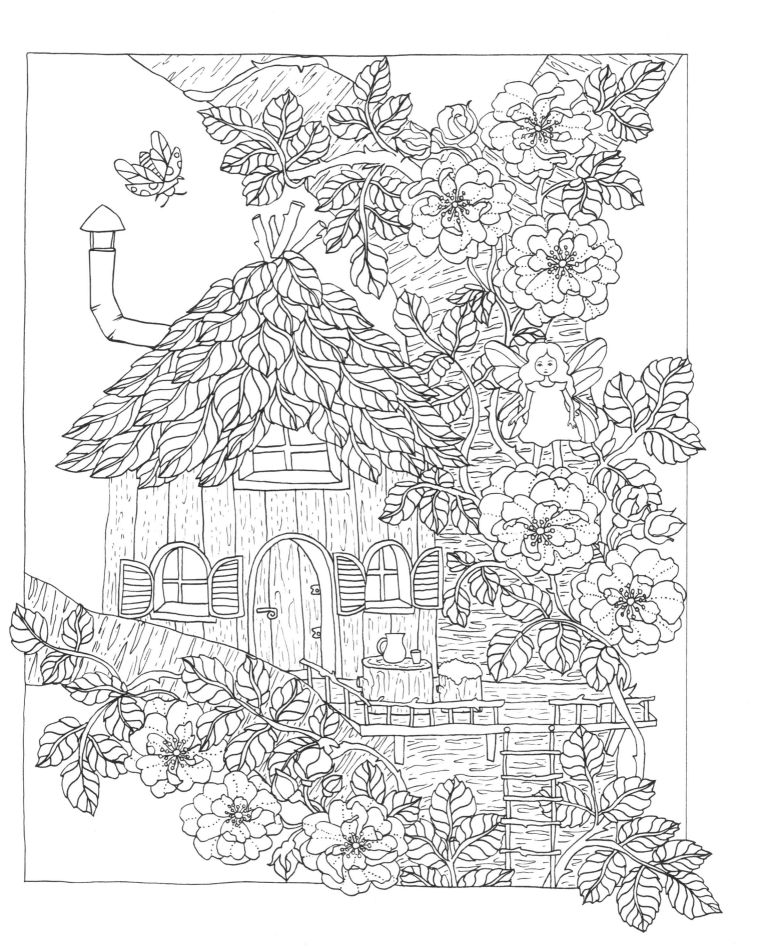

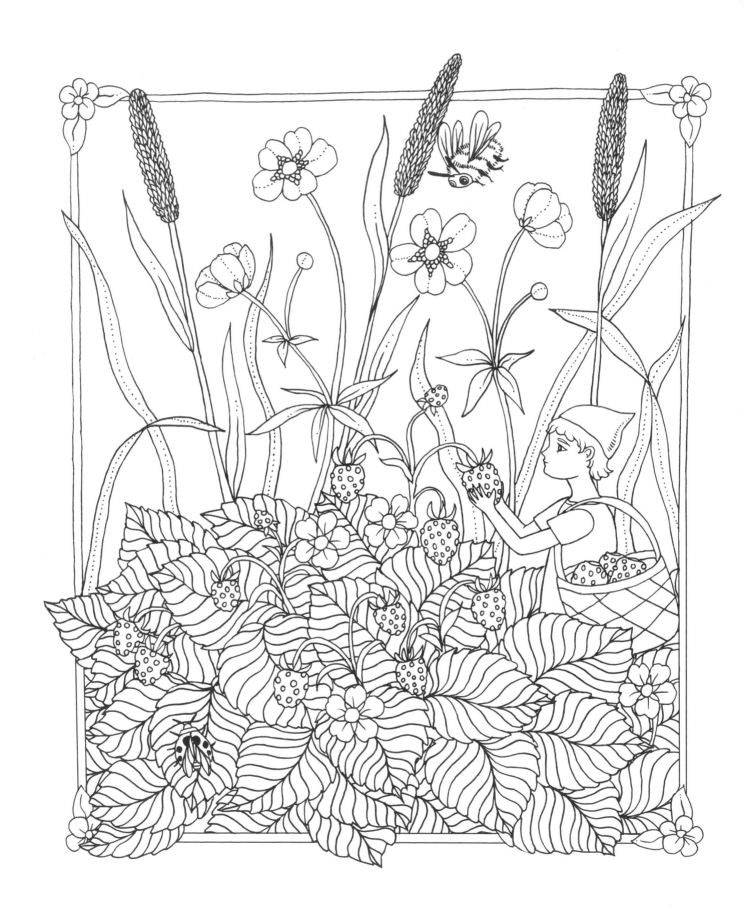

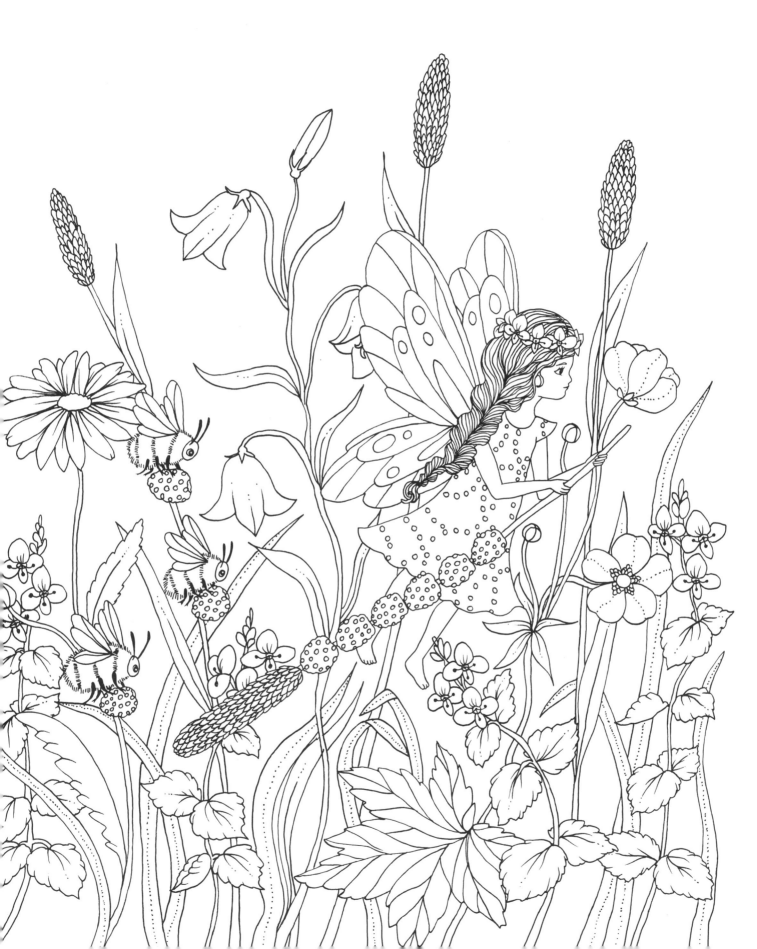

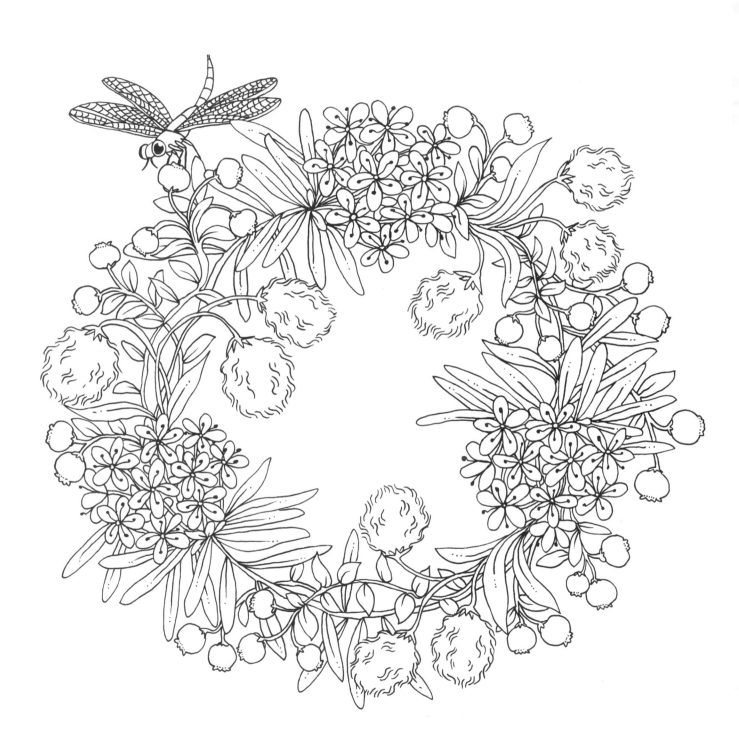

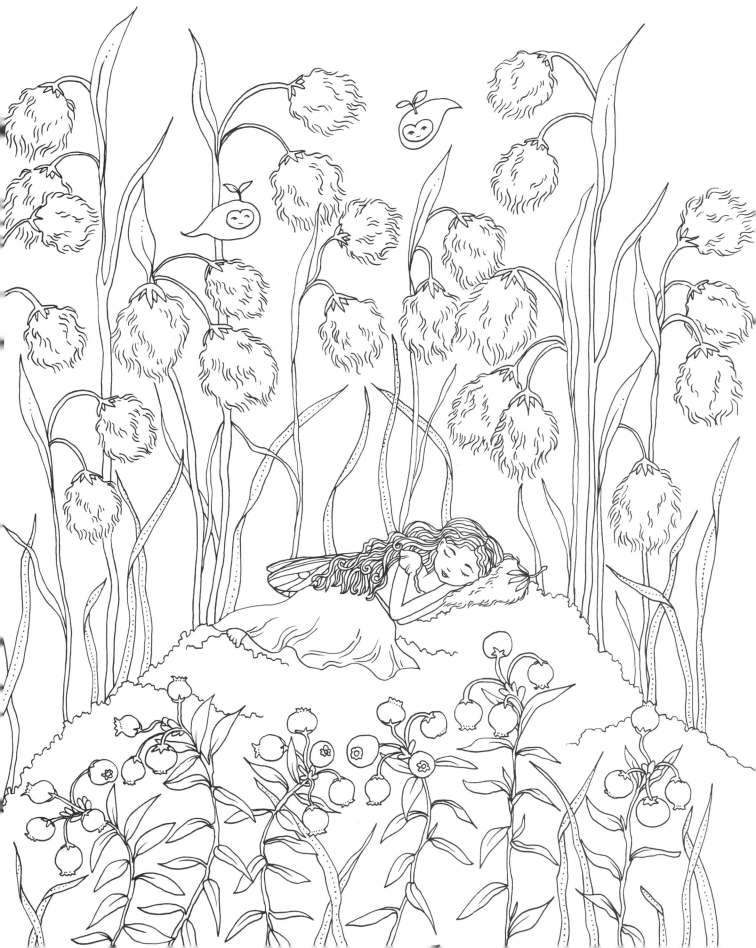

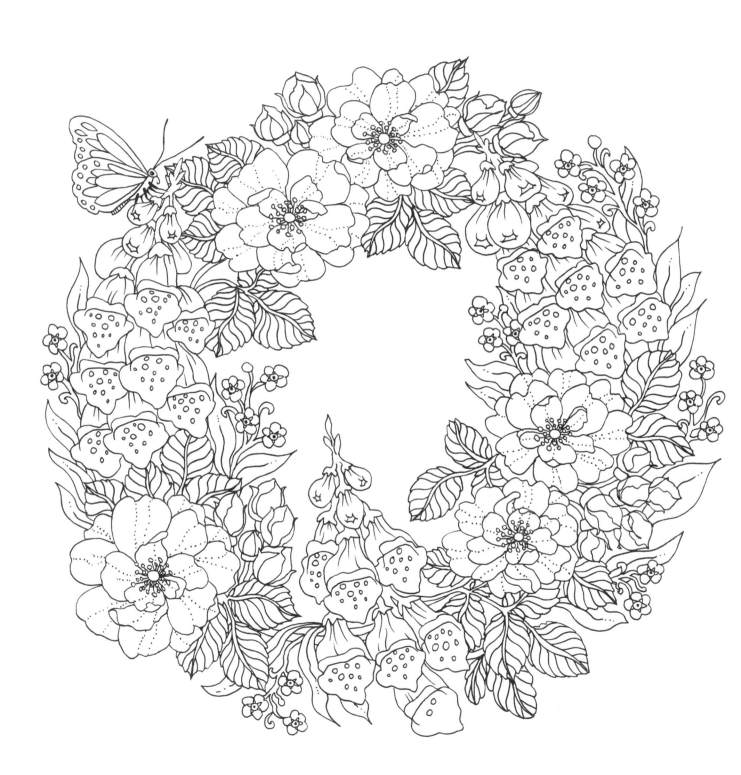

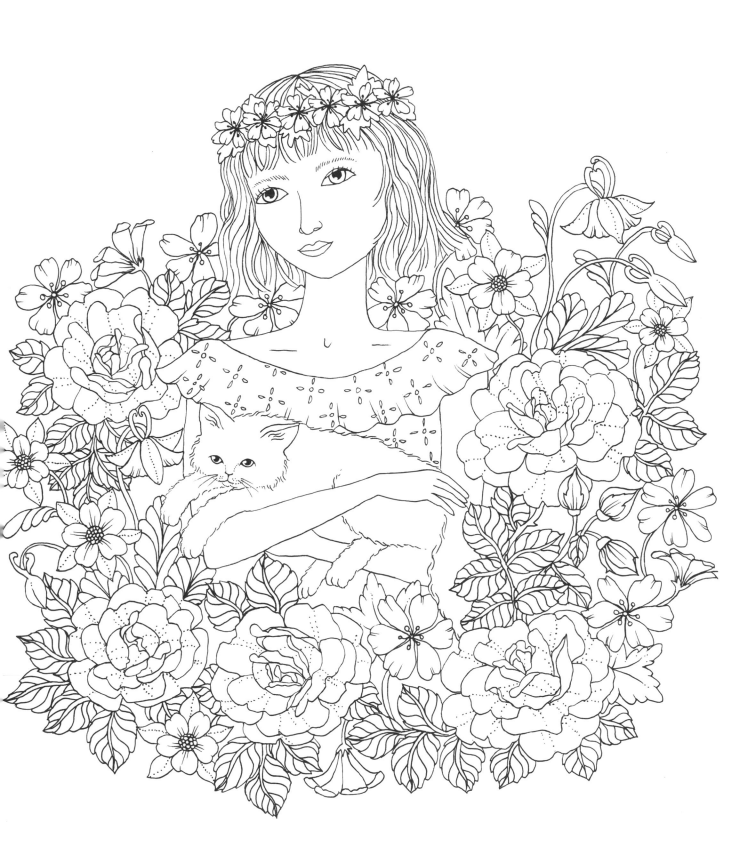

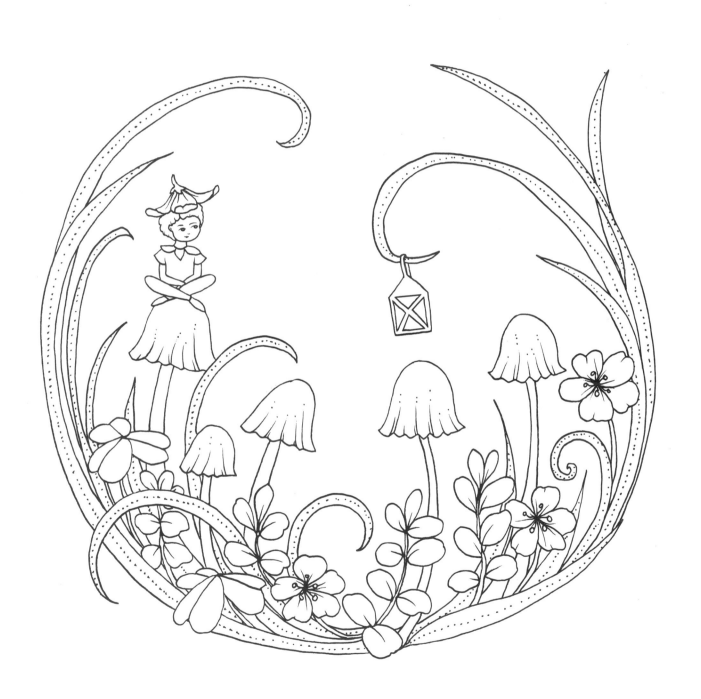

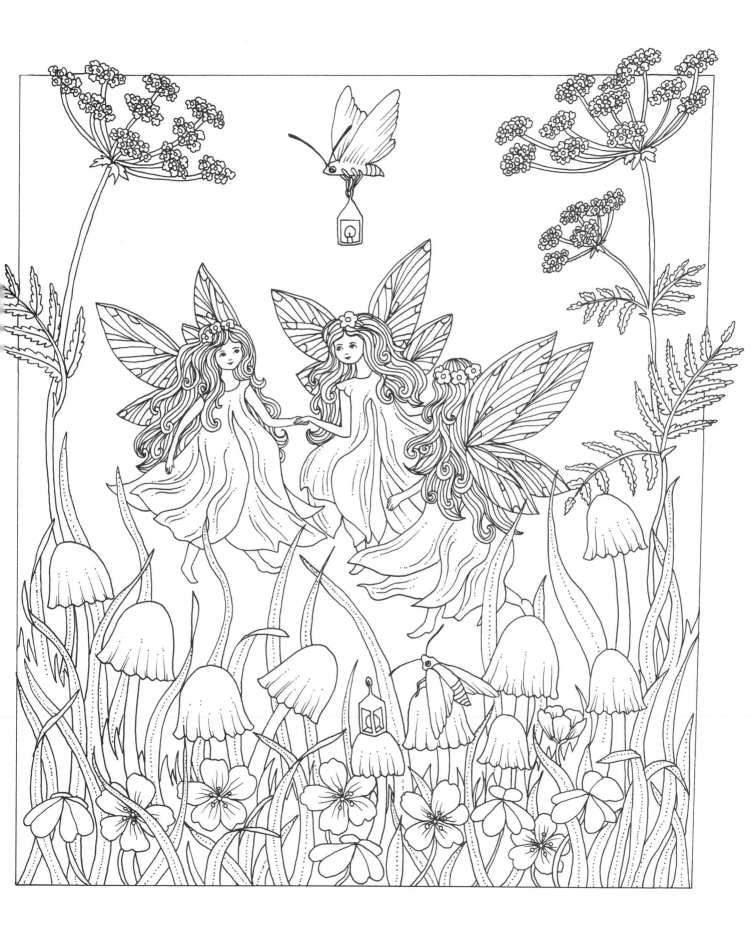

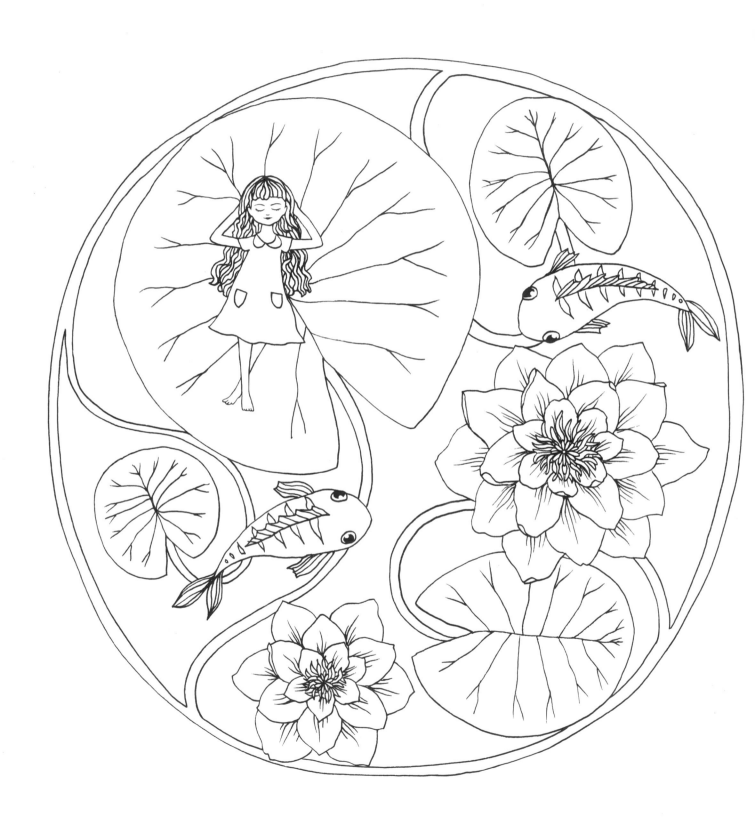

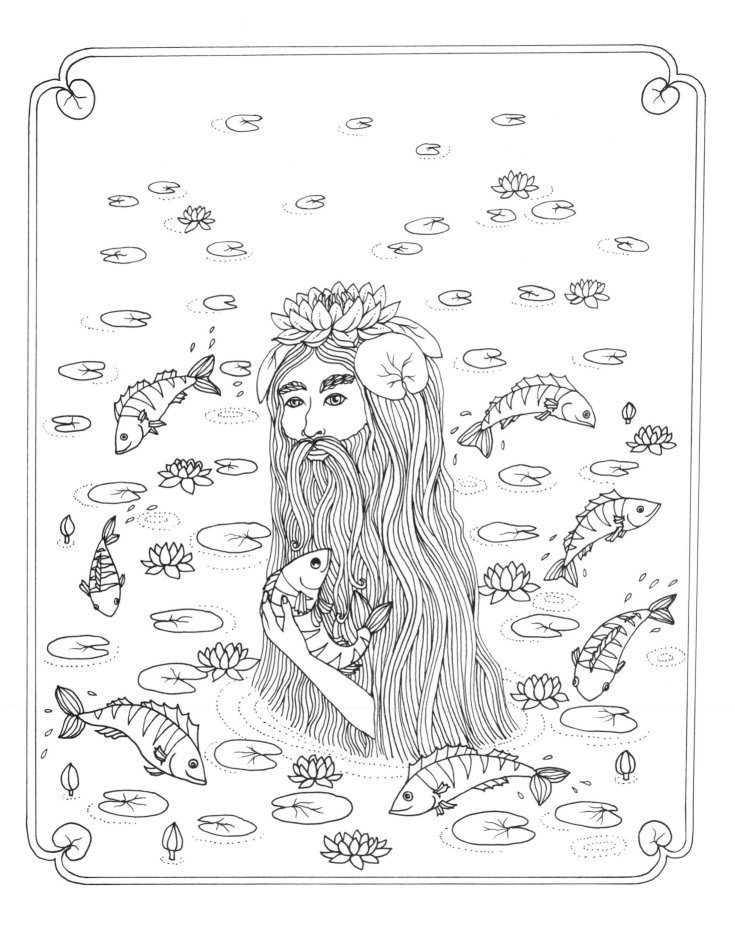

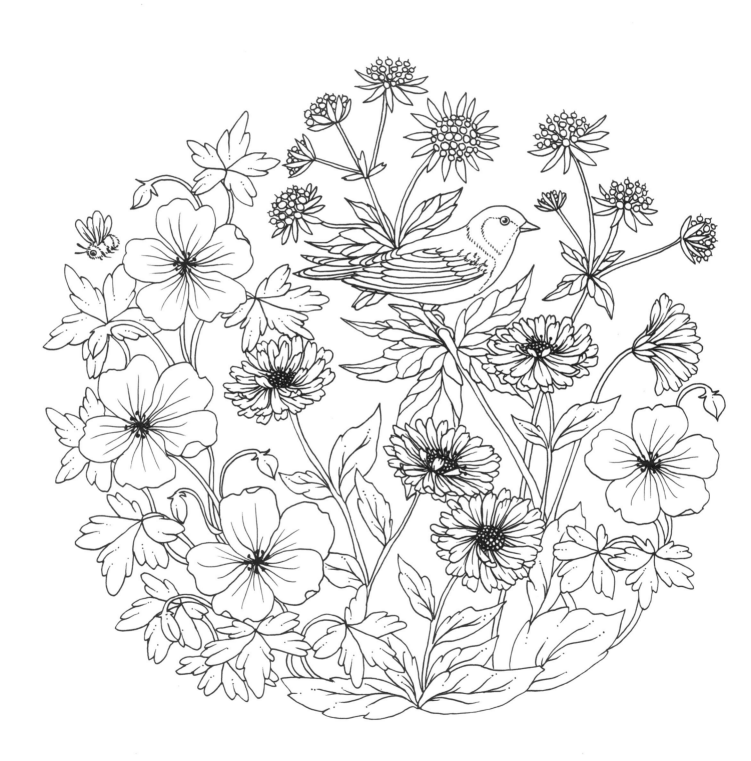

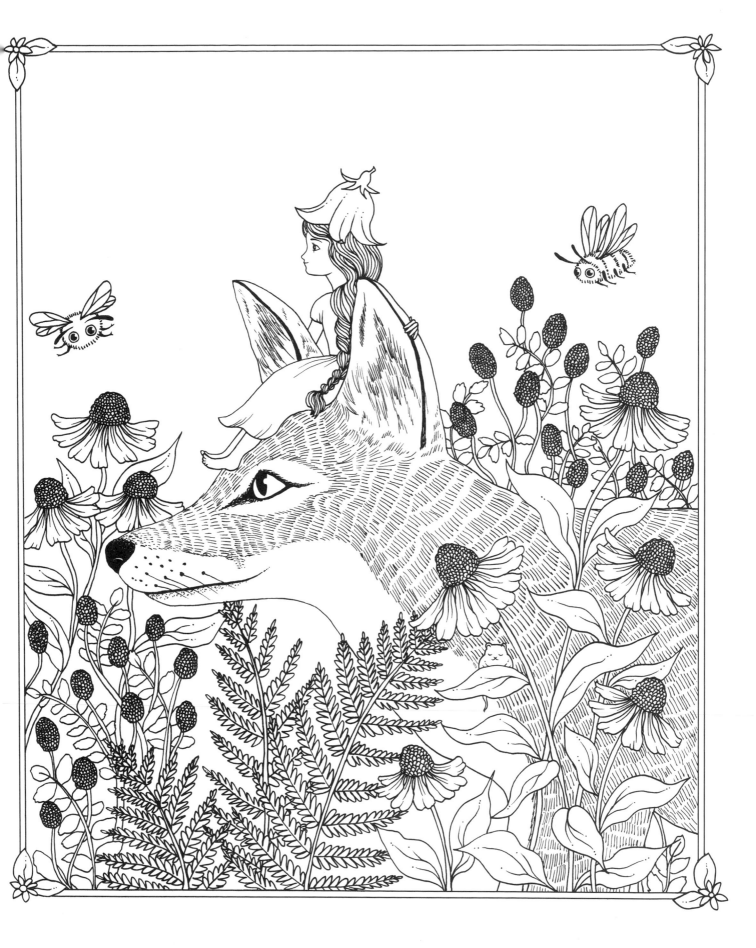

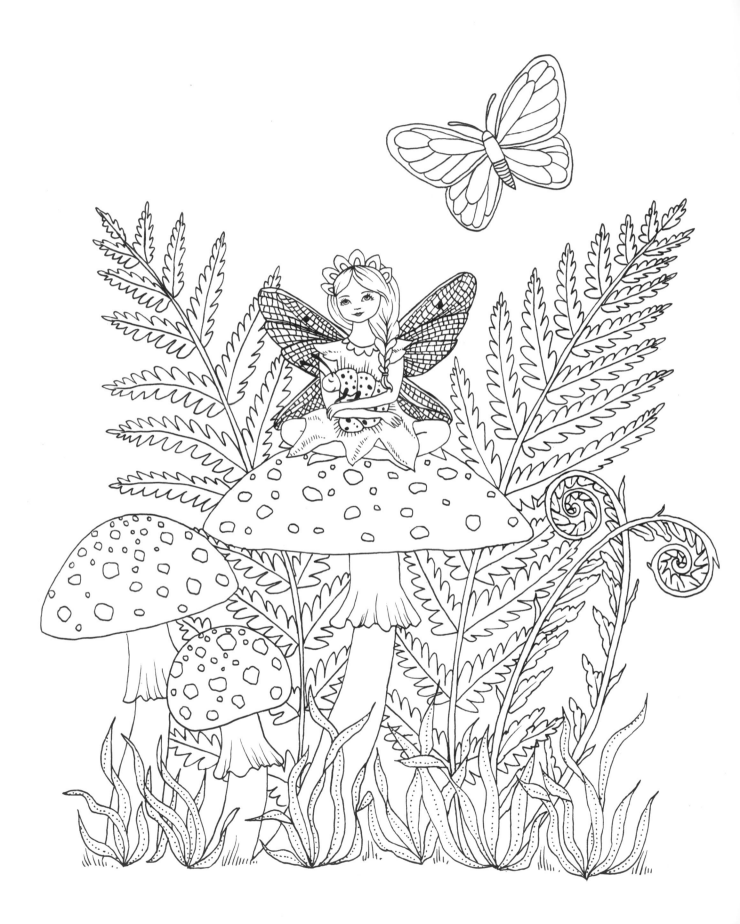

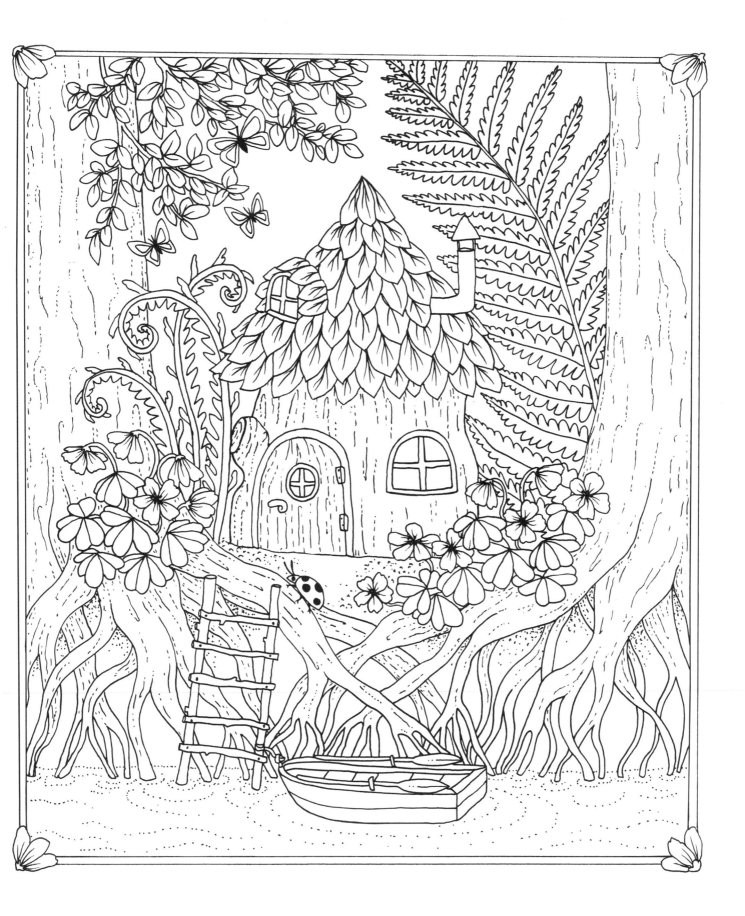

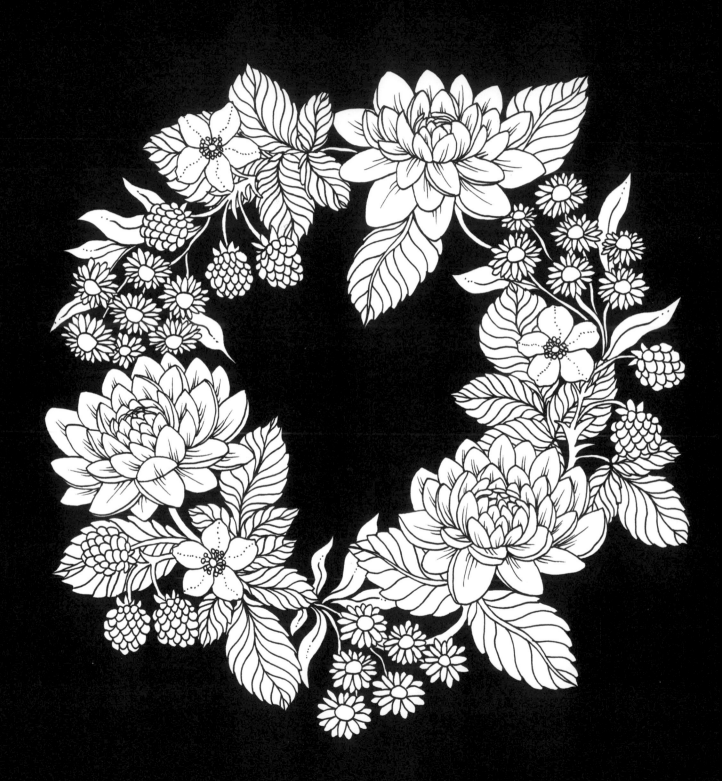

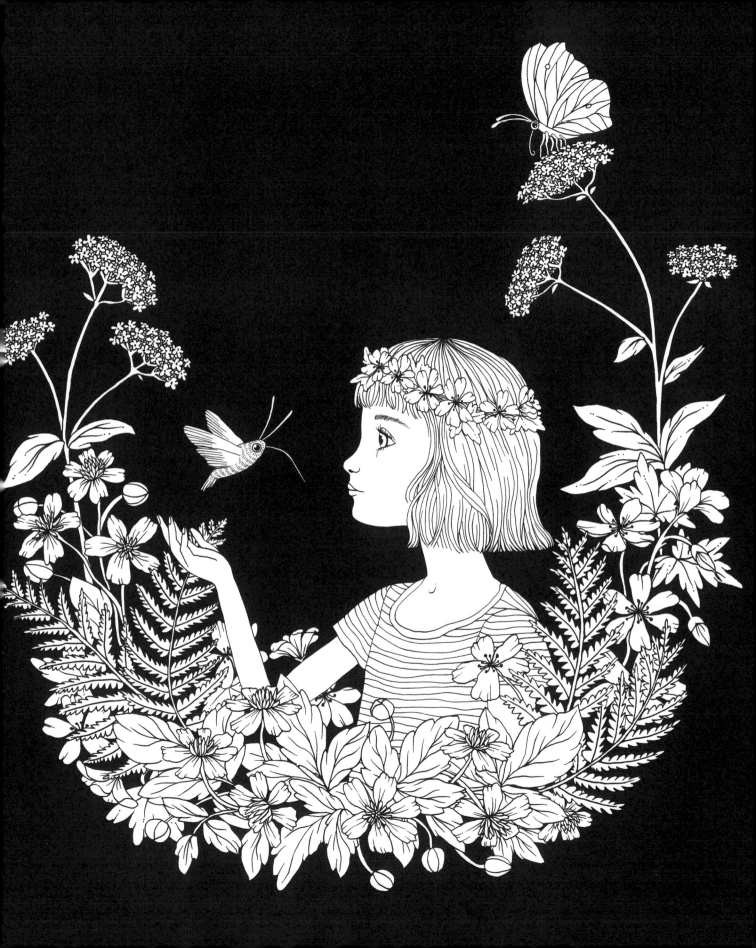

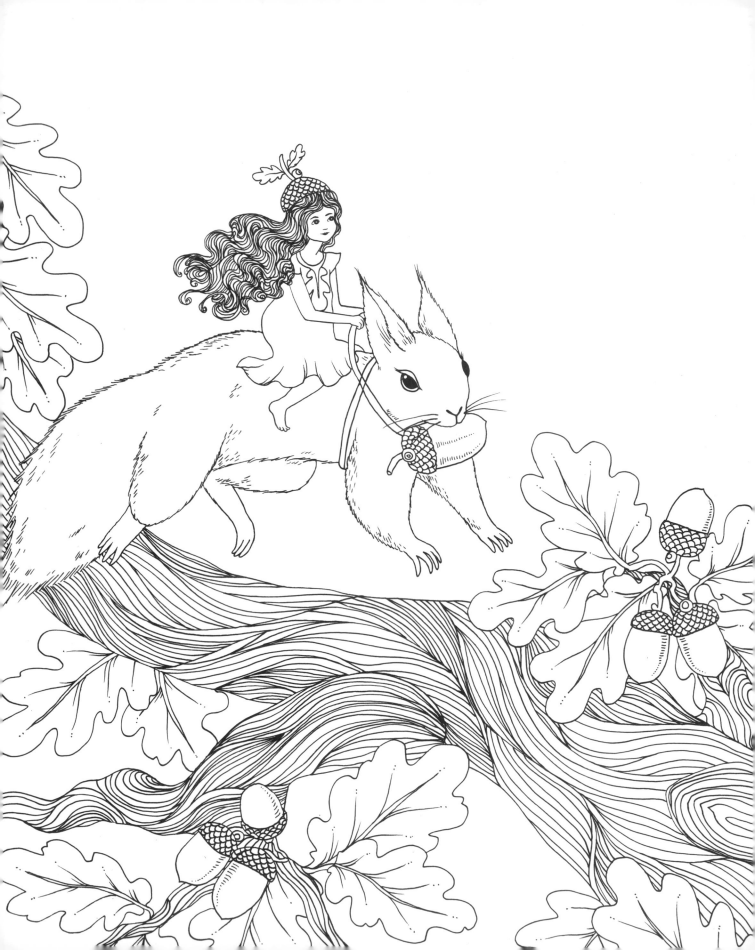

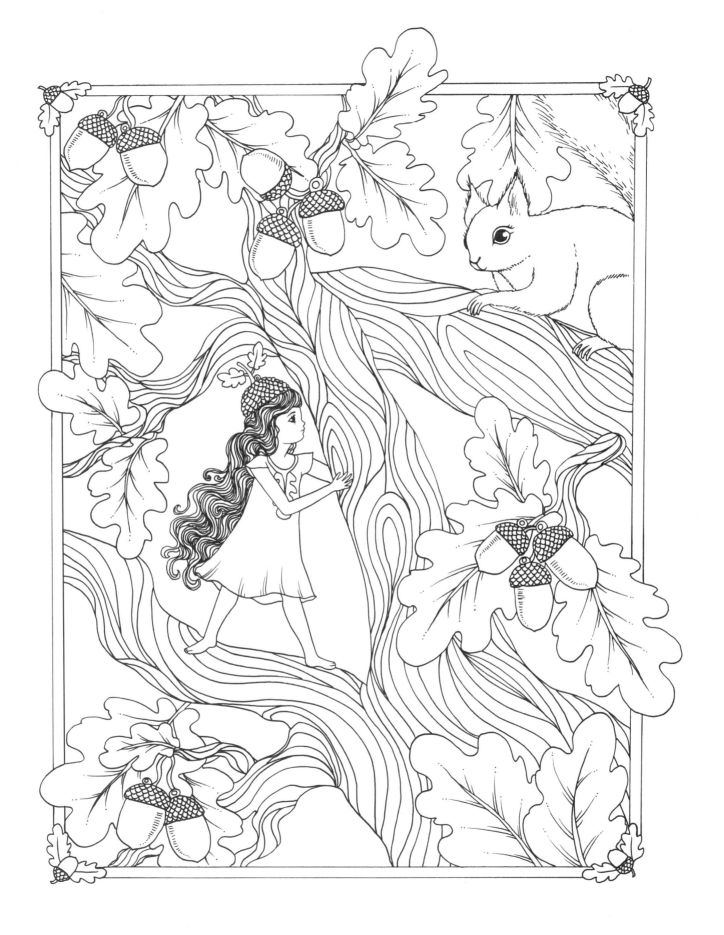

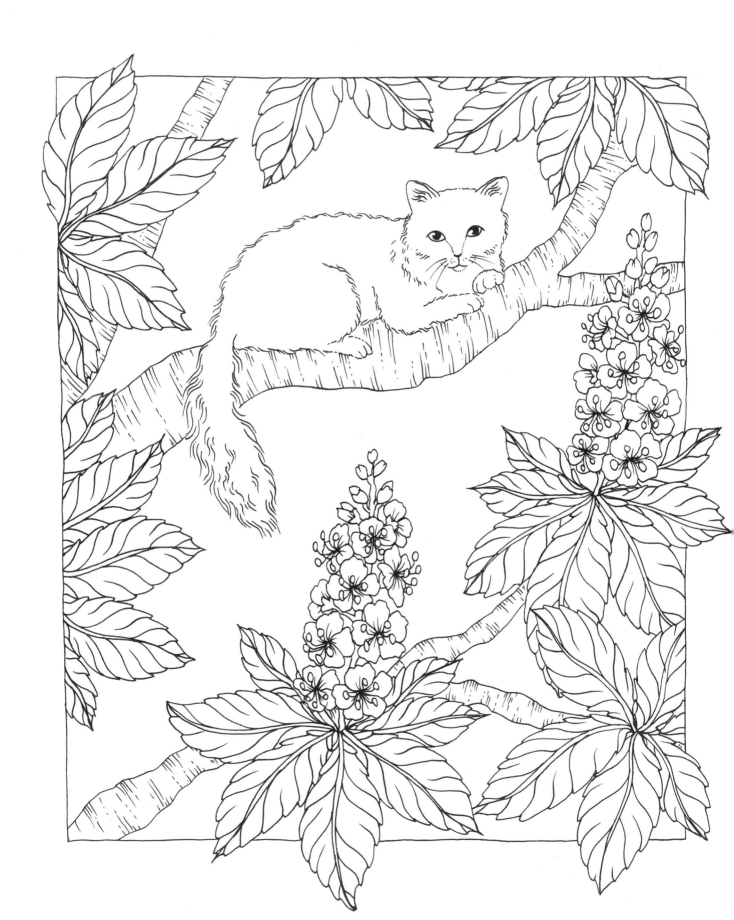

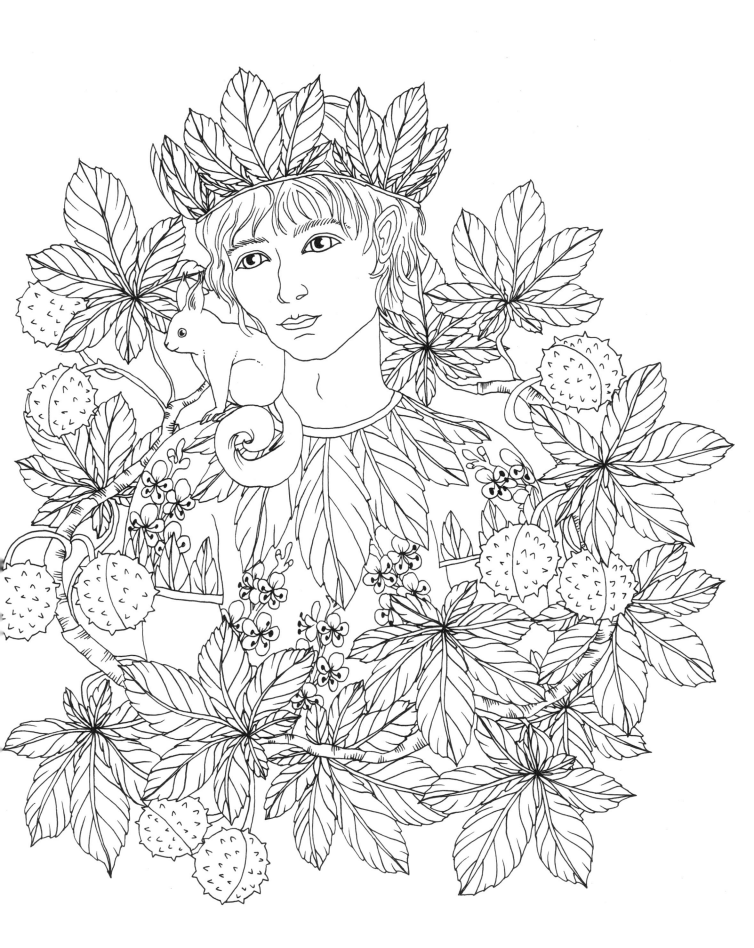

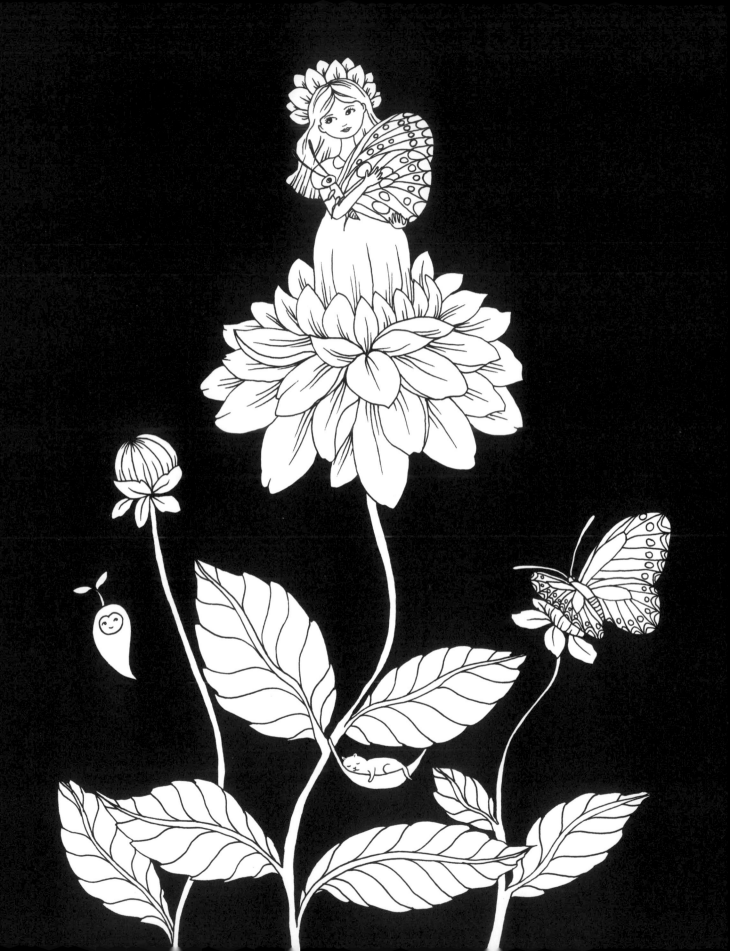

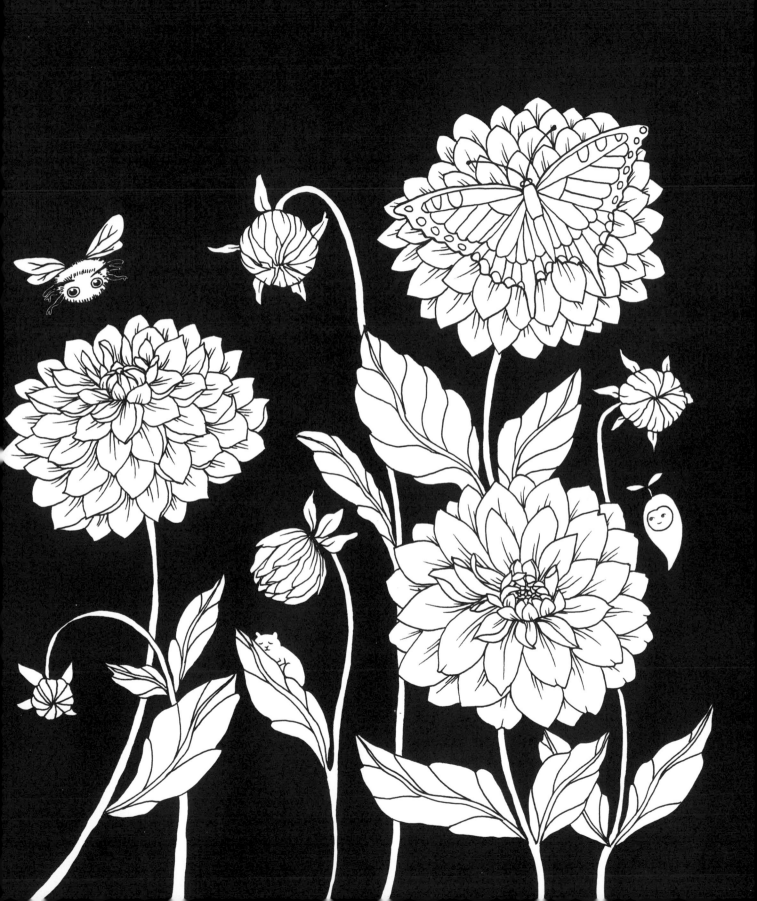

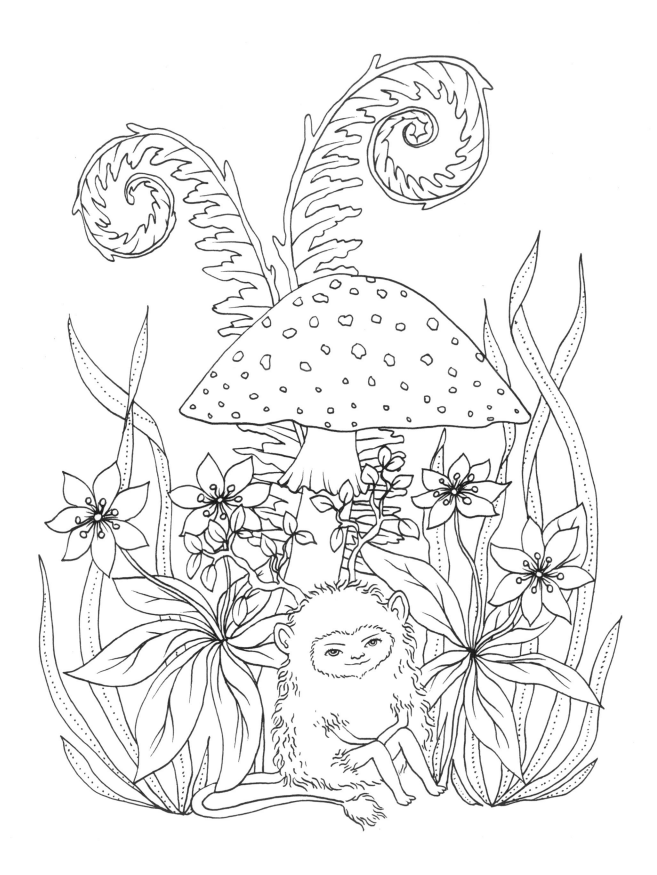

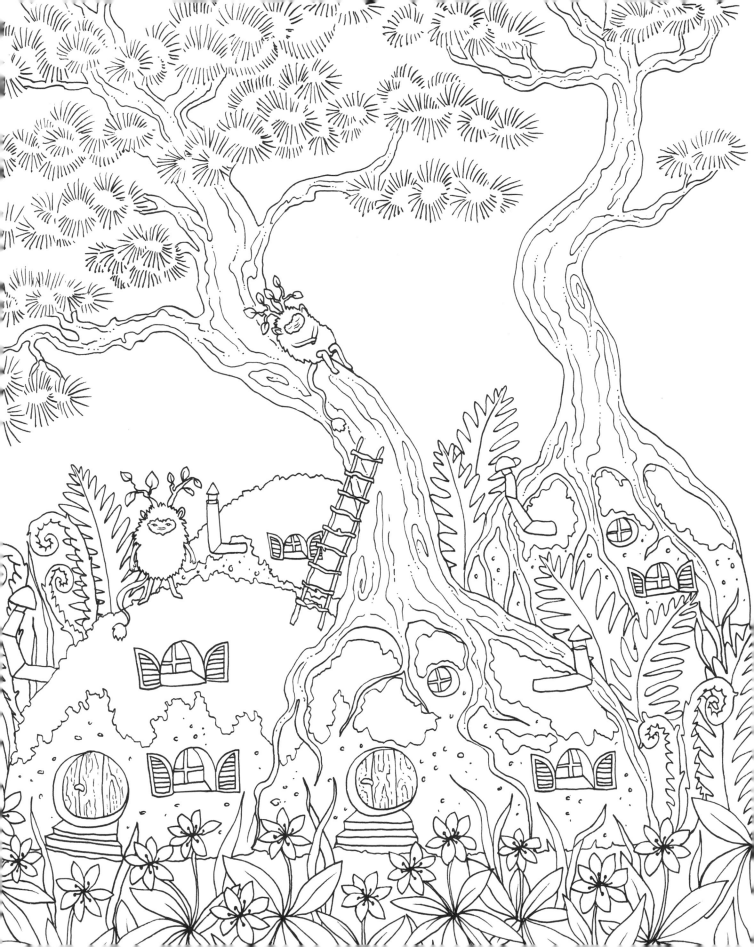

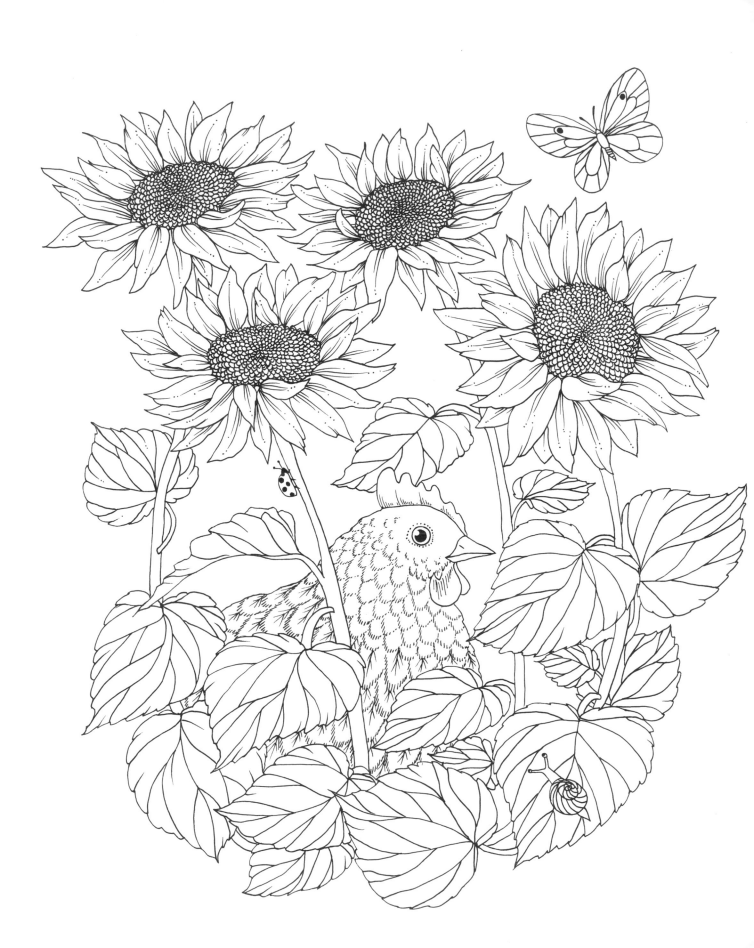

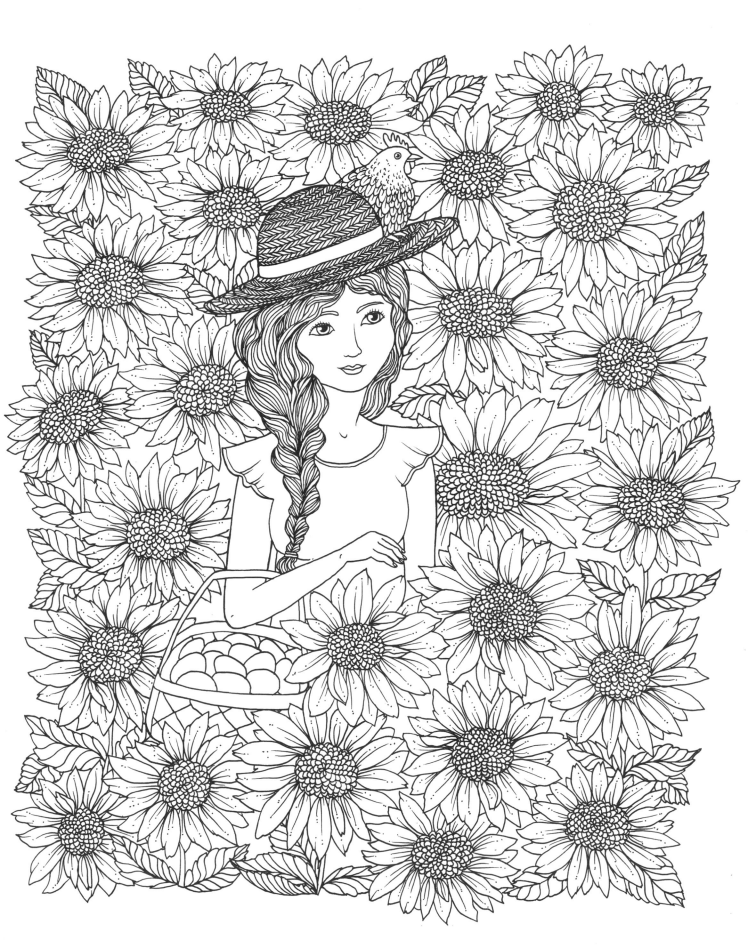

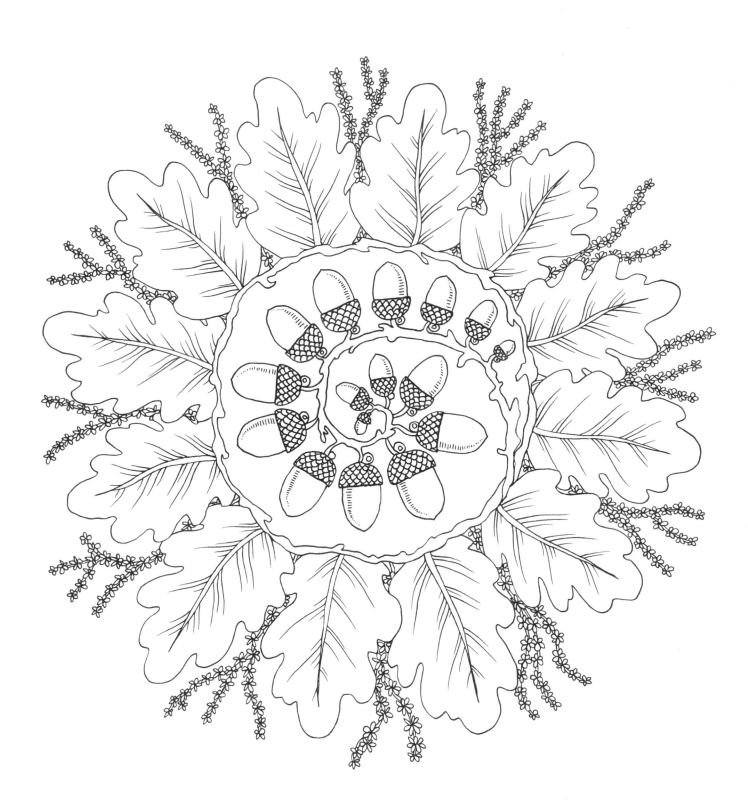

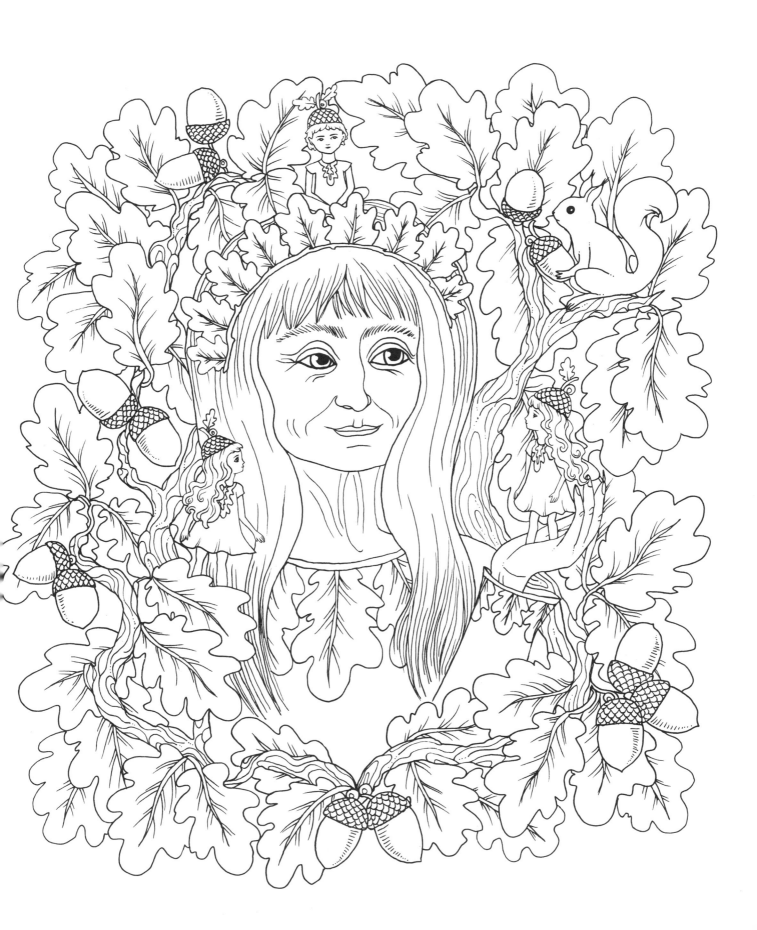

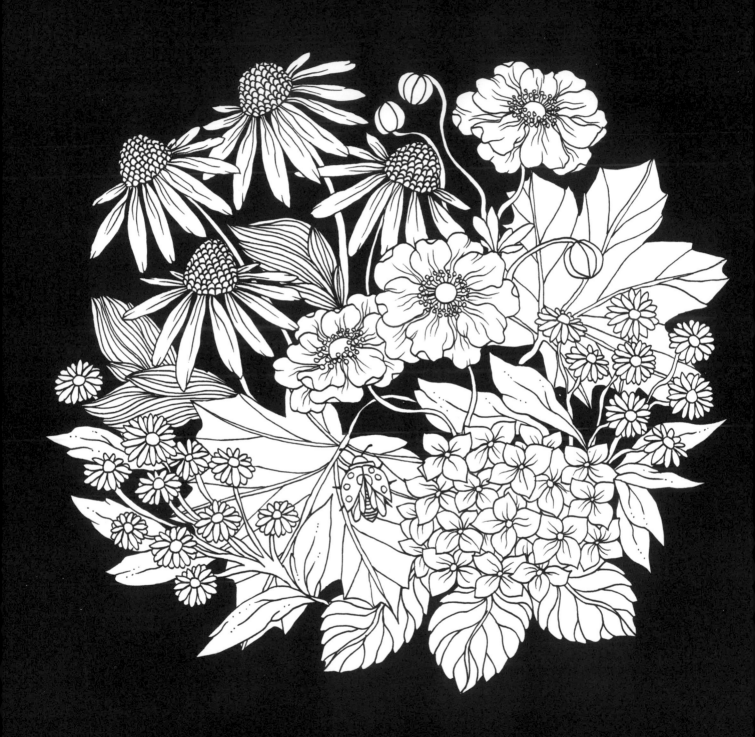

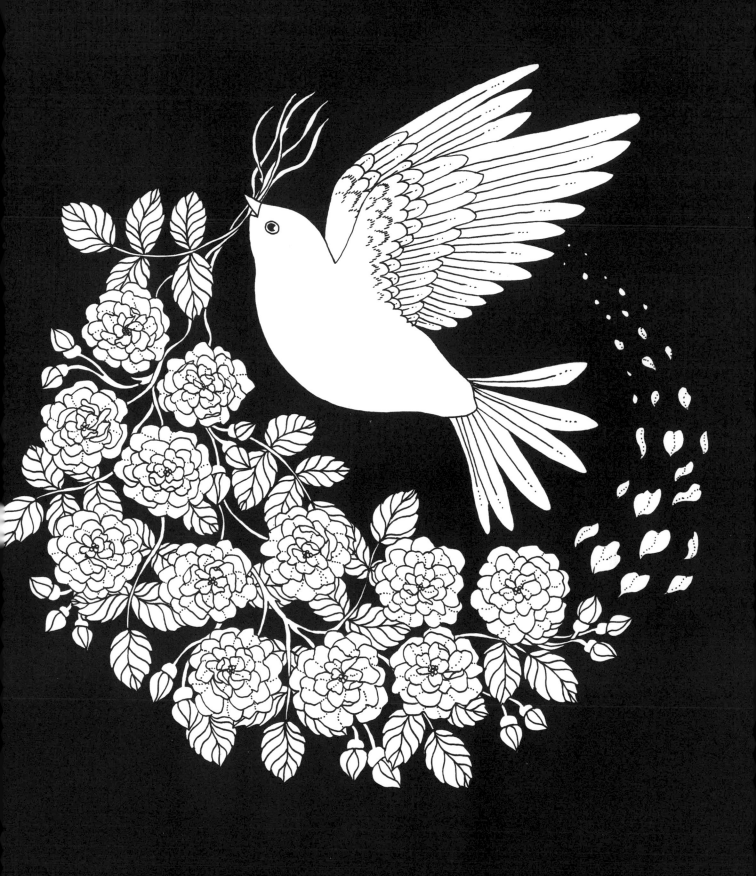

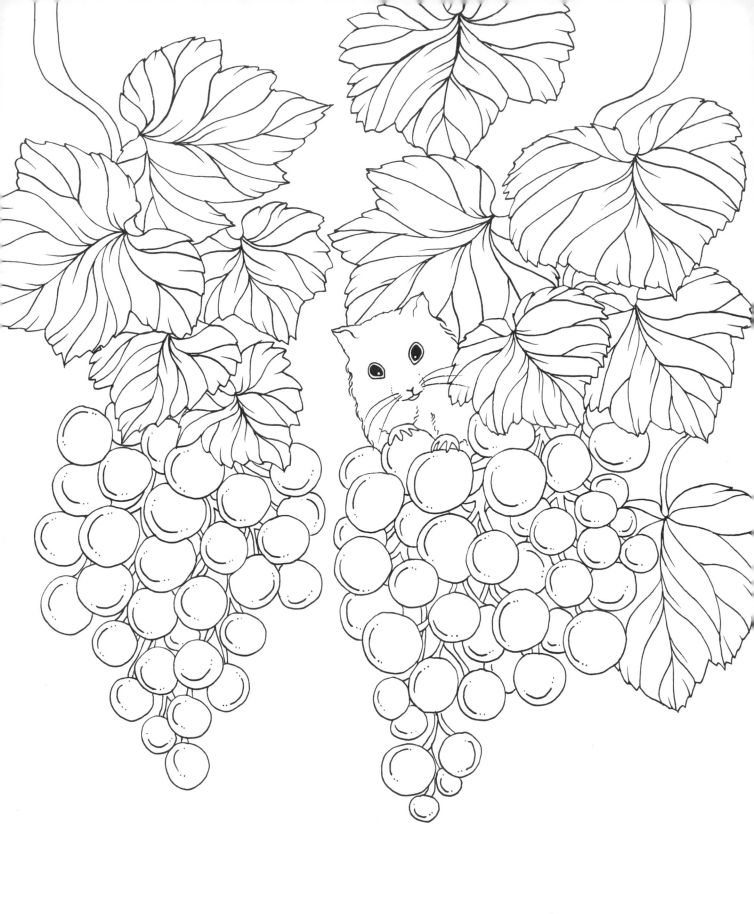

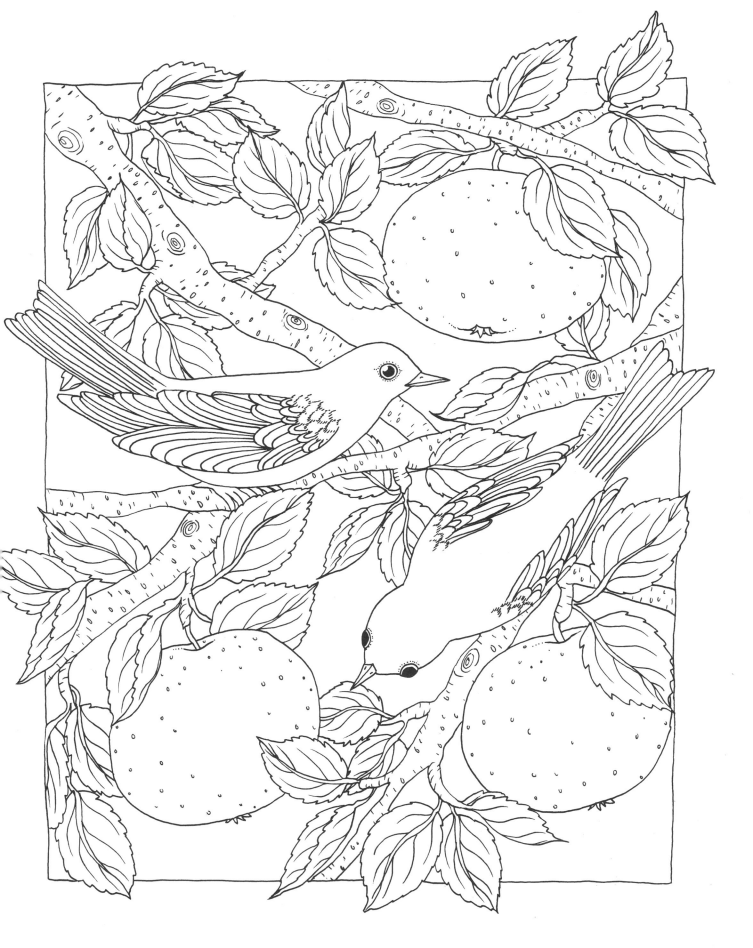

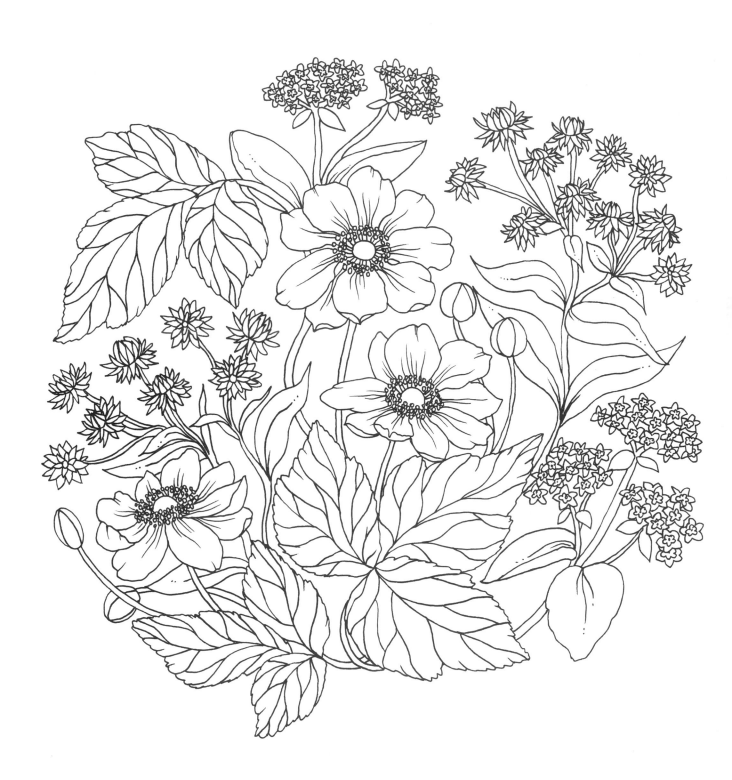

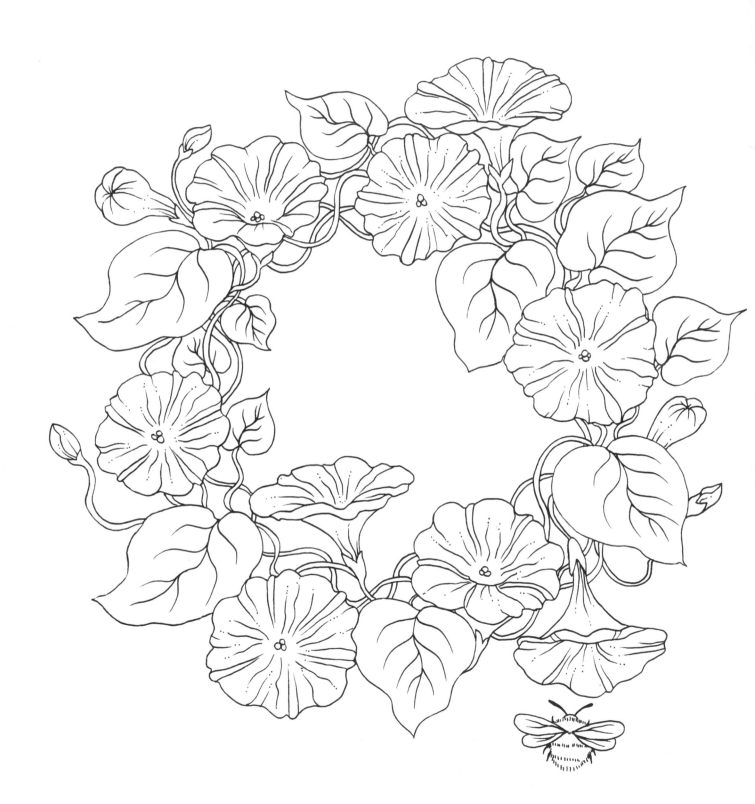

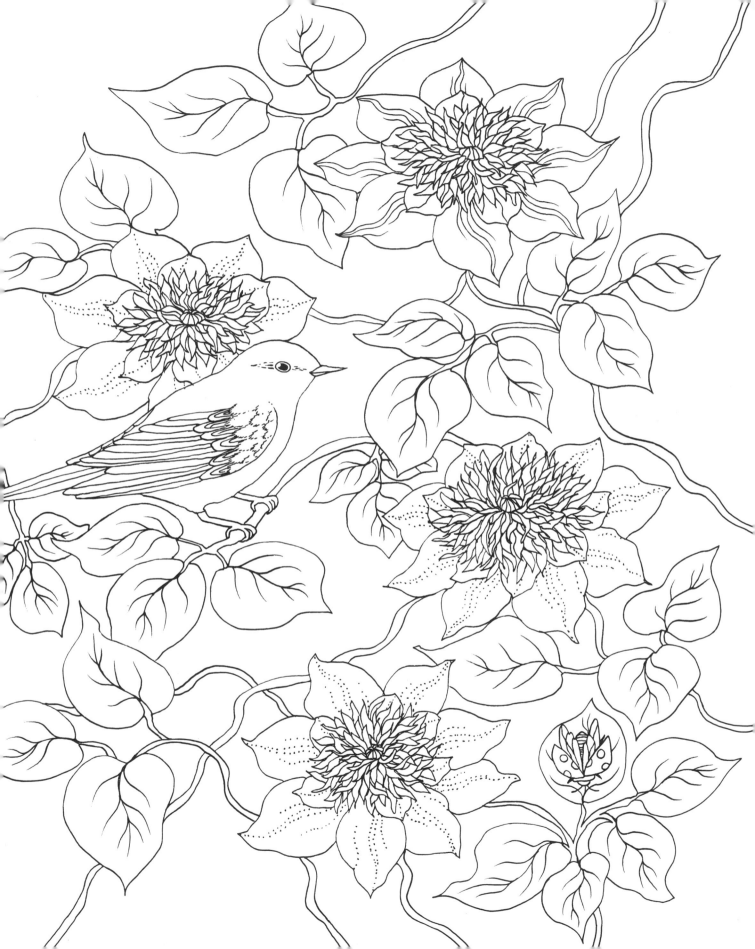

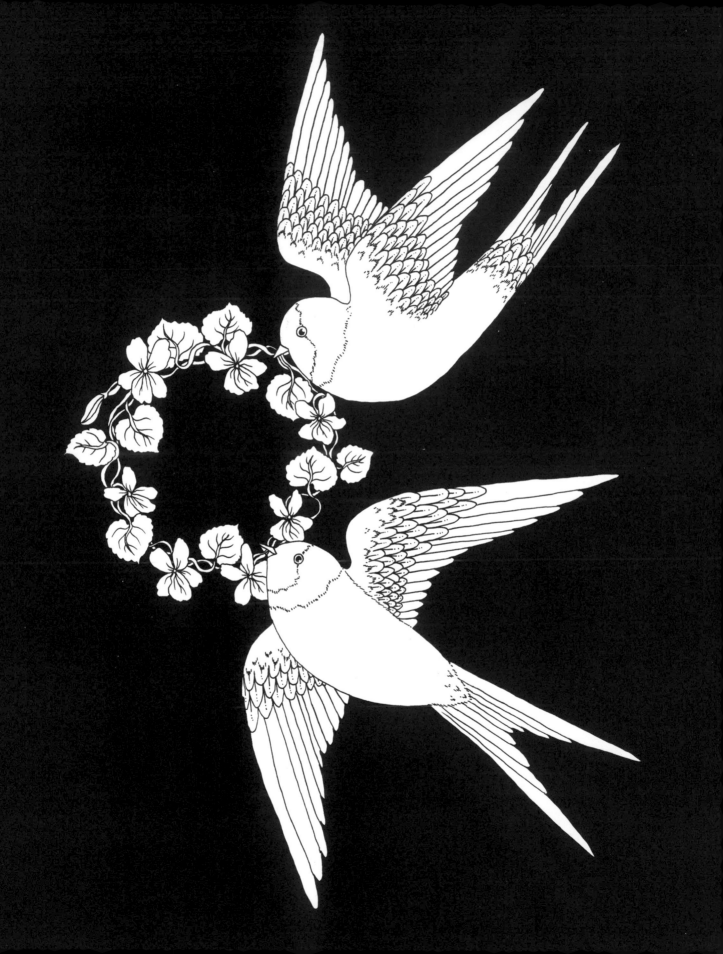

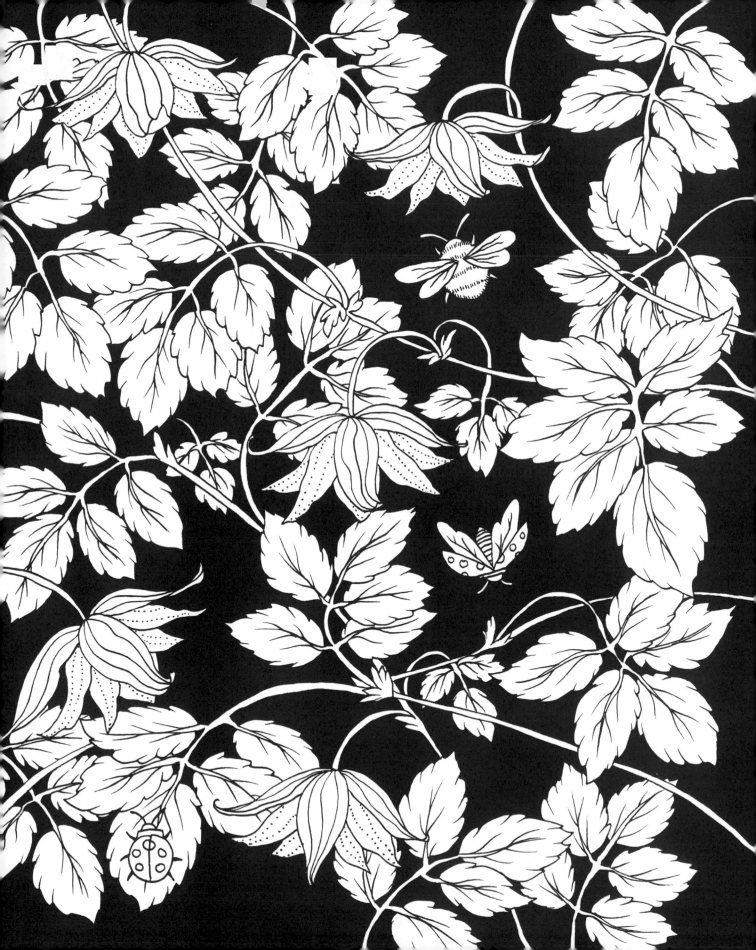

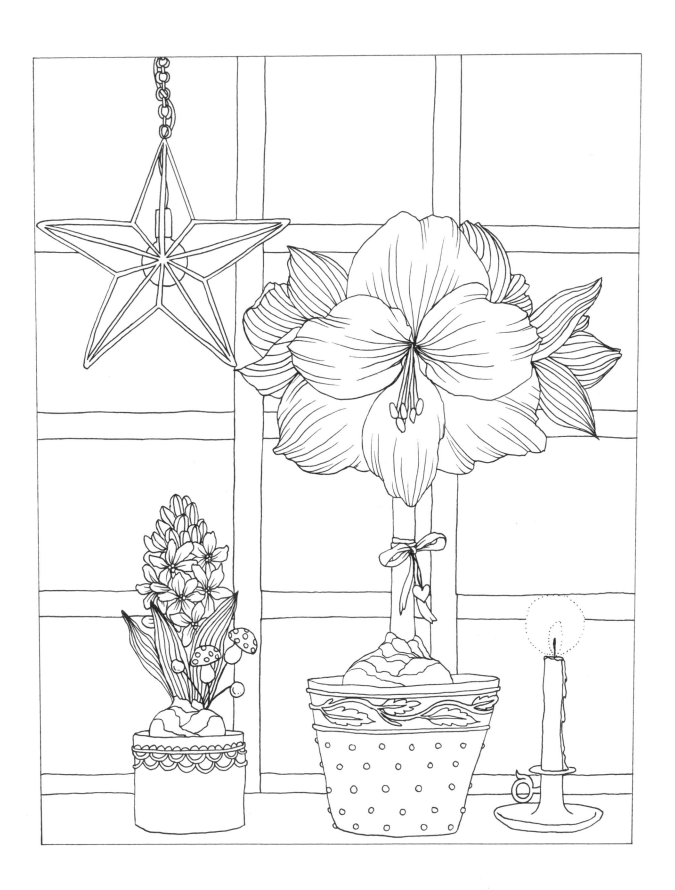

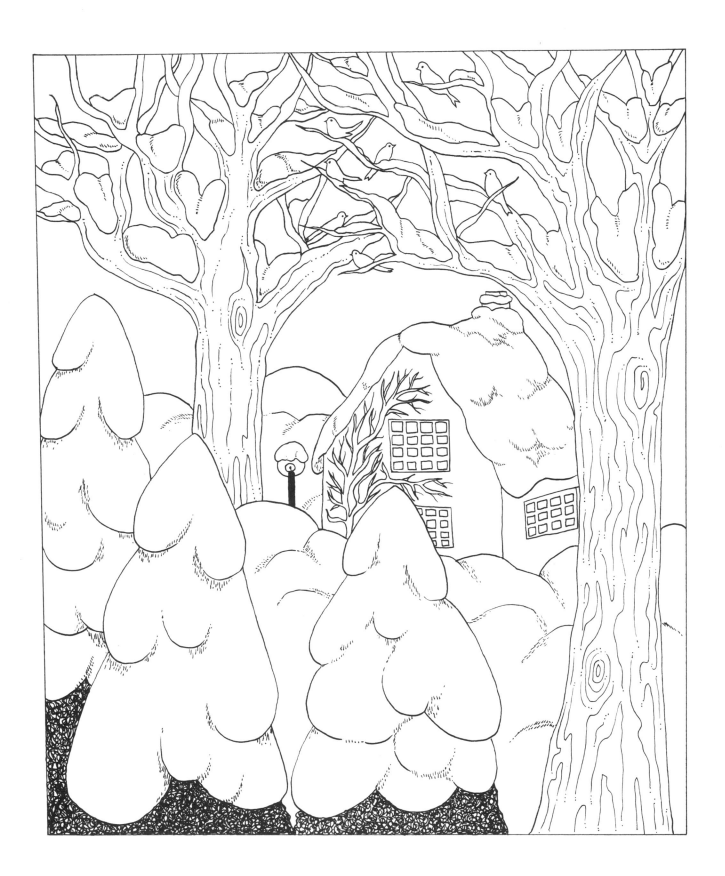

PLANT REGISTER

Plant names listed page by page; numbering begins with the title page as 1.

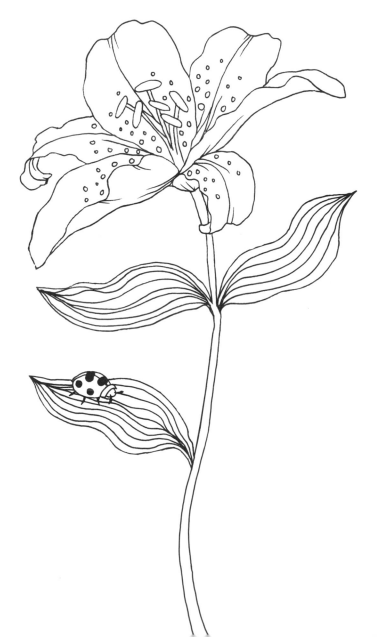

BIRDS, INSECTS, AND AMPHIBIANS REGISTER

Other animals featured:
Fish, deer, squirrel, rabbit, hedgehog, cat, forest mouse, and fox.

TEST YOUR PENS HERE.

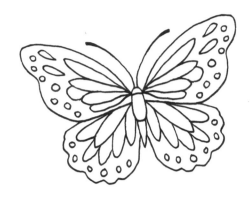

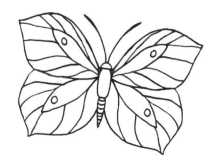